# NATURE
# TONIC

JOCELYN DE KWANT

# NATURE
# TONIC

## A YEAR IN MY
## MINDFUL LIFE

ILLUSTRATED BY
CLARE OWEN

First published in the UK in 2019 by
*Leaping Hare Press*
An imprint of The Quarto Group
The Old Brewery, 6 Blundell Street
London N7 9BH, United Kingdom
T (0)20 7700 6700 F (0)20 7700 8066
www.QuartoKnows.com

Text © 2019 Jocelyn de Kwant
Design and layout © 2019 Quarto Publishing plc

British Library Cataloguing-in-Publication Data
A catalogue record for this book is available from the
British Library

ISBN: 978-1-78240-786-7

This book was conceived, designed and produced by
*Leaping Hare Press*
58 West Street, Brighton BN1 2RA, United Kingdom
*Publisher*  Susan Kelly
*Art Director*  James Lawrence
*Editorial Director*  Tom Kitch
*Commissioning Editor*  Monica Perdoni
*Design Manager*  Anna Stevens
*Project Editor*  Joanna Bentley
*Designer*  Tonwen Jones

Printed in China

10  9  8  7  6  5  4  3  2  1

# CONTENTS

# INTRODUCTION

A few years ago I was a bit down. It was
vacation time and the sun was shining, but
there were a number of unpleasant things
going on in my life and I was angry with
someone. In that condition, I was ruminating
in a lavish Spanish garden, a garden full of
flowers, although I didn't really see them.
They were just there. Then my eyes locked on
a wilted bloom on an ornamental flowering
plant. When I looked a little longer, I saw
more wilted flowers. And I also saw buds
that could burst any moment, and a wilted
flower that had already become some kind
of black fruit, carrying the seeds for the
future generation of that plant. It struck me
that all stages of life were living happily
together on one bush. Without thinking much
about it, I picked a few flowers and arranged
them in the right order on the floor from bud
to fruit. That looked so nice that I took a
picture of it. In the meantime, this whole
procedure had made me so happy, so light and
cheerful, that I had already forgotten how
bleak I had felt when I started it.

That day in the Spanish garden I realized that I missed nature deeply. I had been such a nature lover as a child, going on early morning excursions to hear birds singing and spending hours identifying butterflies and plants. What had happened? Like most of us, I joined the fast city life, reaching for the stars, spending my days among bricks and stones, working frantically from my desk. I had forgotten the feeling nature gave me.

For a long time, most of us have probably thought that nature is nice for recreation but no more important than that. But in recent years scientific research has shown that nature can alleviate a lot of modern problems. If we're cut off from nature, it has a radical impact on our nervous system and higher brain functioning. Depression, anxiety, attention deficit hyperactivity disorder (ADHD), obesity—these are all linked to "nature deficit disorder," an expression coined by Richard Louv, author of *Last Child in the Woods*. In another important book on

the subject, *Nature Fix*, Florence Williams
writes about a Finnish study that showed that
spending five hours in nature every month
could prevent depression. But even just 15
to 45 minutes in a city park were found to
improve mood and vitality. The more I read
about it, the more it convinced me that my
Spanish garden experience wasn't special at
all; it's just what happens when you interact
with nature. It lowers your stress levels
and improves well-being, creativity, and
life satisfaction.

After experiencing a burnout 15 years ago,
I have dedicated my work as a journalist
to writing about things that make you feel
better. I've tried everything and spoken
to many experts in the field. I've studied
mindfulness; I've simplified my life; I've
investigated how creativity can help. And all
of that was beneficial. However, discovering
the recent research about the positive impact
of nature—and there is a lot—it feels as if
I've found the holy grail of well-being. It's

really simple. If we want to stay sane in
this world, if we want to refrain from being
overwhelmed, we've got to return to nature.
But what can we do, apart from the occasional
visit to the woods?

For this book, I've made 365 prompts for a
nature moment a day. Prompts to meditate,
to look, to learn, or to do. I've combined
mindfulness, creativity, botanical
curiosity, and bush craft. Follow the pace
of the book and pick a different one every
day, or just pick a couple that work for
you and repeat them as often as you want. It
doesn't matter, as long as you do something
daily. Some prompts end with the suggestion
of drawing something; but don't worry, it's
not about the artistic quality. Drawing is
just meant as a tool to encourage you to look
closer; you could also take a photograph.

That day in the Spanish garden was the start
of a new journey. I can honestly say it has
changed my life for the better.

# A NATURAL RHYTHM

Watches and planners: we can't live without them. Of course, they are useful, but slowly they've started to dominate our lives. We're always rushing from one place to the next; we treat every day, every hour, as if it's the same, trying to force ourselves into a mold that isn't natural for us. We sometimes forget that things have not always been this way. The clock is a human invention—and we certainly didn't evolve with a phone attached to our hand.

Not so long ago, measured time played a far more modest role in our lives. We were more dependent on nature and subsequently more in sync with the seasons and the natural course of the day. Maybe the first and most crucial step in reconnecting with nature is to get back in touch with the natural rhythm of the world. As the researcher Yoshifumi Miyazaki points out: "Throughout our

evolution, we've spent 99.9 percent of the time
in nature. Our physiology is still adapted to
it. During everyday life, a feeling of comfort
can be achieved if our rhythms are synchronized
with those of the environment."

Don't worry, this is not about throwing away
your planner and ditching your watch. This
is about realizing that we could all benefit
from living life at a more natural pace. This
chapter is about noticing the natural rhythm
of the world, seeing how the day changes, how
the seasons change, how nature adapts to the
earth's orbit around the sun; because we could
definitely learn a thing or two from nature when
it comes to adapting to our circumstances. There
is a time to bloom, to grow, to hibernate; there
is a time to harvest. We can slow down and accept
that every moment has its own quality.

A NATURAL RHYTHM

**1.**
...

Arrange a day without any commitments and let yourself become one with the natural flow of the day. Try not to look at the clock. Sleep when you feel tired; eat when you feel hungry. Try to spend time outside. **Make little notes during the day about how this feels.**

**2.**
....

The sound of birds singing as loudly as they can just before sunrise is known as the "dawn chorus." Due to the lack of wind in those predawn hours, female birds can better identify the different males, because each has a unique song. The male birds might also be trying to prove they are the toughest by being able to sing so energetically so early in the morning. If you get the chance, wake up with the dawn chorus.

**3.**
....

Studies show that listening to birdsong can lead to improvements in our mood and mental alertness. There are thousands of recordings available online that can help boost your spirit on a working day.

# 4.
....

Every part of the day comes with its own different sounds. Keep track of the soundtrack today. **Which sounds are typical for which point of the day? Note the hours.**

**Morning**

.........................................................

.........................................................

.........................................................

**Midday**

.........................................................

.........................................................

.........................................................

**Afternoon**

.........................................................

.........................................................

.........................................................

**Evening**

.........................................................

.........................................................

.........................................................

# 5.
....

Before artificial lighting, there was little more to do than reflect, talk, and sleep after the sun had set. Things changed a lot after the invention of the lightbulb. People started to move daytime activities into the night. Since then, we've started to miss valuable hours for reflection. Today, don't turn the lights on just yet. Reflect on the day, alone or with someone, and go to bed the moment you feel tired. **Write about the experience.**

.........................................................

.........................................................

.........................................................

.........................................................

.........................................................

## 6.

There are many more ways to look at the time than just by seeing the minutes tick by on the clock. The Greeks made a distinction between *chronos*, the time measured, and *kairos*, the "right time" to seize the moment. *Kairos* is not about "having" time; it's about making time. **Think of something you love doing, then take a break from *chronos* and lose yourself in the activity.**

## 7.

Time seems to move faster or slower depending on the events taking place and our mood. Sometimes it feels like time stands still. **Describe a moment in your life when your inner time behaved differently from clock time.**

# 8.
....

All living creatures have clocks inside; biological devices controlled by genes, hormones, the cycle of day and night, and so on. Our internal clock affects our moods, desires, appetite, and energy. It's OK to be lazy sometimes and respect your natural rhythm! **Think about the following:**

**When do you feel most energized?**

_____

_____

_____

_____

**Are you a morning or an evening person?**

_____

_____

_____

_____

**What is generally your most difficult hour?**

_____

_____

_____

_____

_____

Yellow woodland anemone
(*Anemone ranunculoides*)

Dandelion
(*Taraxacum officinale*)

Morning glory
(*Ipomoea*)

Evening primrose
(*Oenothera biennis*)

## 9.
....

Even flowers have a way of telling you the time. Many
flowers, such as dandelions, yellow anemones, and
violas, close their petals or bow their heads when the
sun sets. Some flowers, such as the morning glory, are
strict about their opening hours. It opens its head at
5 a.m. and closes around noon. The evening primrose, on
the other hand, opens its flowers every evening only at
around 6 or 7 p.m. **Notice the opening and closing times
of flowers today.**

# 10.

Not all flowers react to the weather by closing their petals. Some flowers, such as magnolias and gardenias, are protected by a thin waxy coating, so their nectar will not be harmed when it's cold or wet. Look for flowers that are always open, even on a rainy day. **Draw or glue one here.**

# 11.

Pretend this drawing of a house represents your home. Draw arrows indicating north, south, east, and west. **Where does the sun set?**

# 12.

For a sunny day: In the morning, turn your head to face the sun and close your eyes. Repeat this at around noon and in the evening. Notice the difference in the intensity and warmth. **What is the effect of the sunlight on your face? Describe the feeling.**

..................................................................................................

..................................................................................................

..................................................................................................

..................................................................................................

## 13.
......

Although we talk about four seasons, ecologists actually distinguish six. The prevernal season is when tree leaf buds begin to swell. You can smell that spring is coming, but it's not actually here yet. We know the vernal season as spring. This is when the buds burst open to reveal leaves. The peak of summer, when the trees are in full leaf, is called the aestival season. During the serotinal season, the leaves begin to change color. In the autumnal season, the leaves start to fall. In the hibernal season, the trees are bare and the leaves begin to decay. **Write down five observations on what is typical of the season at this time of year where you live. They can be related to plants, the weather, or wildlife.**

## 14.
......

To adapt to the changing of the
seasons from summer to fall, then
winter, without the sad feeling that
sometimes accompanies the fewer hours
of sunlight, it helps if we spend as
much time as we can outside. Think of
smart ways you can spend more time
outdoors. Get off at an earlier bus stop
and walk the rest of your journey. Spend
your breaks outside. Avoid tunnels and
choose to travel or do things outdoors
whenever you can.

## 15.
......

Zoom out. Where is your
place on this planet?
Where would you like
to be right now?

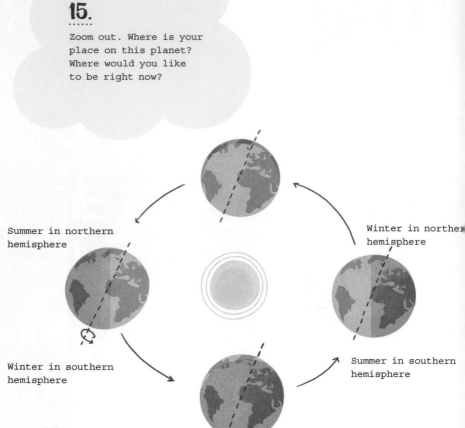

Summer in northern
hemisphere

Winter in northern
hemisphere

Winter in southern
hemisphere

Summer in southern
hemisphere

## 16.
......

It's fascinating that because of the way the earth is tilted
on its axis, different parts of the world experience different
seasons. Near the equator, there are wet and dry seasons.
In the polar regions, there are the dark and light seasons.
In the height of the dark season, the sun doesn't appear at
all. And then there is everything in between, as well as
differences because of land or sea climate. **Describe the
seasons in your country.**

....................................................................................................................

....................................................................................................................

....................................................................................................................

....................................................................................................................

## 17.

You can tell a lot about nature by watching birds. If you see them flying in big groups in one direction, it signals a change in the season. Most flocks form a perfect "V" shape when traveling. It is believed that they fly like this to save energy, because each bird can catch the updraft created by the bird in front of it. It's beautiful to watch. It's also a lovely simple thing to sketch. **Draw a flock of birds, with little V shapes making up a larger V.**

## 18.

The seasons have always been seen as a metaphor for life. **To which season do you feel most connected right now and why?**

............................................

............................................

............................................

............................................

............................................

## 19.

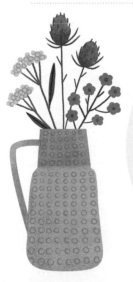

A simple practice to connect with the seasons is to bring a little piece of them inside. This doesn't have to be an abundantly decorated seasonal table; it can be as simple as a nice vase with some blossoming weeds you find outside.

## 20.
.......

What produce does this season offer you? Sometimes eating seasonal fruit and vegetables is just what you need. When you live in a country with cold winters, for example, and you eat kale, a winter vegetable, your body gets the iron that it needs. **Find out what fruit and vegetables are seasonal right now and prepare a meal or snack with some of them.**

## 21.
.......

Every season has its own smell. Go outside and let your nose do the exploring. **What scent do you associate with this season?**

# 22.

In Japan the Cherry Blossom Festival, called *Hanami* ("Watching flowers"), is celebrated by picnicking under the trees on the first weekend the blossom appears. *Hanami* symbolizes the coming and going of beauty, because the blossom lasts only two weeks. When we realize something is temporary, we appreciate it more. **Draw a picnic scene under this blossoming cherry tree and, as you do, reminisce about a beautiful spring moment.**

# 23.

When the blossoms fall from the trees and cover the ground with a blanket of spring confetti, the next stage begins—the phase of spring cleaning. Out with the old; in with the new. You can also practice spring cleaning for your mind. **Which thoughts no longer have a good reason to occupy your mind? Which can you let go?**

## 24.

The chirp of cicadas is probably one of the sounds most associated with summer. Cicadas are real musicians, making their song by rubbing the upper and lower parts of their wings together. Listening to the repetitive sound of cicadas can put you in a meditative state. You can find lengthy recordings of cicada song online, and you can use these as the focus of a summer meditation. **Sit in a comfortable position with your eyes closed and gently straighten your back. Listen to live or recorded cicadas. Every time your mind starts to wander, bring your attention back to the sound.**

## 25.

Think of the seasons in terms of sounds. Does the sound of the sea make you think of summer, for example? **What noises do you connect with each season?**

# 26.
.......

"There are always flowers for those who want to see them," said the famous French painter Henri Matisse. Go outside and look for flowers along the roadside. Bring some home to sketch or glue here. **Even better, sit outside and paint them.**

## 27.
.......

At the end of its blooming period,
every tree and plant has a way of
sending its seeds out into the world.
Some stick, some fly with the wind,
and some are a treat for animals
and find their way to a new place
in animal droppings. Go on a hunt
for seeds and collect a couple of
different examples. **Draw one or two
of them here. Note how you think they
find their way out into the world.**

## 28.
.......

Investigate a seed. Can you separate
out different parts? What type of
parts does it consist of?

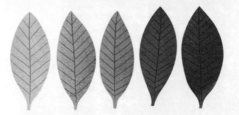

## 29.
......

Look at the way leaves change color, for example, how the leaves in fall can change from green to red to brown. Some leaves even turn white. In springtime, they can change from light green to darker green. But this change in color is not the only one caused by the changing of the seasons. During a dry period, for example, trees may also ditch their leaves to protect themselves. Find leaves from the same tree that have different colors. **Draw or paste them here.**

## 30.
......

Ferns are true survivors. They grow almost everywhere and they've been around for millions of years. Young fern leaves start out curled up in a ball. When they grow, they slowly unroll. It's beautiful to see. **When have you felt yourself unfurling?**

# 31.
......

The changing of the seasons has inspired artists since the beginning of civilization right up to the twenty-first century. Dutch designer Jurianne Matter picks colors by strolling through nature. From her daily walks, she brings little pieces of nature —a stone, wood, herbs, a pine—back to her studio and then tries to "capture" the colors. **Try this technique to make your own seasonal color palette, and use it for your own nature painting.**

# NOCTURNAL NATURE

The night has a special ability to free us from daytime worries. No one will call or email. People who cause us stress are asleep—in theory, at least. Yet how many of us lie awake at night, worrying about everything and nothing, turning small problems into monsters? To benefit from the calming effect of the night, we need to turn off our screens long before we go to bed. But to settle into the magical state of mind that the night can bring us, we have to go outside.

The stars, the moon, the silence, the darkness —it's all there for us. In the absence of bright lights, your other senses will fill in the gaps. You'll become aware of the soft touch of the night breeze on your skin. What seems like silence turns into an orchestra of natural sounds, if you pay attention: high-pitched

crickets chirping, night owls calling, bats
flying. Darkness will turn into beautiful shades
of blue. If you take a deep breath, you'll smell
the earthy aroma of damp plants and trees.

This chapter gives you the chance to discover
all of these things—to explore the natural world
illuminated only by the silver light of the
moon, to pay attention to the sounds and smells
that the night brings, to look out for nocturnal
creatures—to remind us that even the darkest
night has so much life and wonder in it.

Night is also when we get the chance to look out
into the universe and see other galaxies. If that
doesn't help us realize that our problems are
relative what does? So let us befriend the dark,
and allow it to help us find a sense of calm.

NOCTURNAL NATURE

........................................................

........................................................

........................................................

........................................................

........................................................

# 32.
.......

Go on an evening stroll with a friend just
after sunset. Don't talk, set your phone
to silent mode, and walk more slowly than
you usually would. Inhale deeply. **What do
you smell and what sensations and emotions
do you feel?**

# 33.
.......

The sounds of nature at night are known for
their relaxing powers. Even when there is
traffic noise in the background, noticing
natural sounds can help you to relax. Focus on
the crickets, frogs, owls, and other nocturnal
birds, the fluttering sounds of flying bats on
a search for food, and rustling leaves in the
wind. **Note or draw what you hear.**

## 34.

Whenever you can, sleep with the window open, using earplugs when there is too much noise. A cool bedroom is one of the best ways to get a good night's sleep, and feeling the breeze at night will help you sleep like a baby. In children's day care in many Nordic countries, they often let the babies and toddlers nap outside —under warm blankets, of course.

## 35.

The darkness of the night sky turns into beautiful shades of blue as soon as your eyes are accustomed to the lack of light. These colors are perceived as so magical that they have led to the phenomenon of night paintings. One beautiful example is Van Gogh's *Starry Night*. **Look it up and make your own interpretation just for fun.**

## 36.

Did you know that trees sleep at night? Finnish researchers found that trees relax their branches at night, which they saw as a sign of snoozing. The researchers observed the branches and leaves of silver birches, and found that they sagged up to 4 inches (10 cm) at night. They perked up again just before sunrise. Because the branches lifted up before the sun was up, the researchers concluded that the trees rely on their own internal circadian rhythm. **Take an evening stroll and keep an eye open for the night trees. Do you see the branches sagging a little?**

## 37.

Close your eyes and visualize yourself as a tree. Feel your roots growing into the ground, grounding you. Hold your head up high and as steady as a wise old tree. And just like a tree at night, relax every muscle in your body by dropping it a little. Let go of any tension.

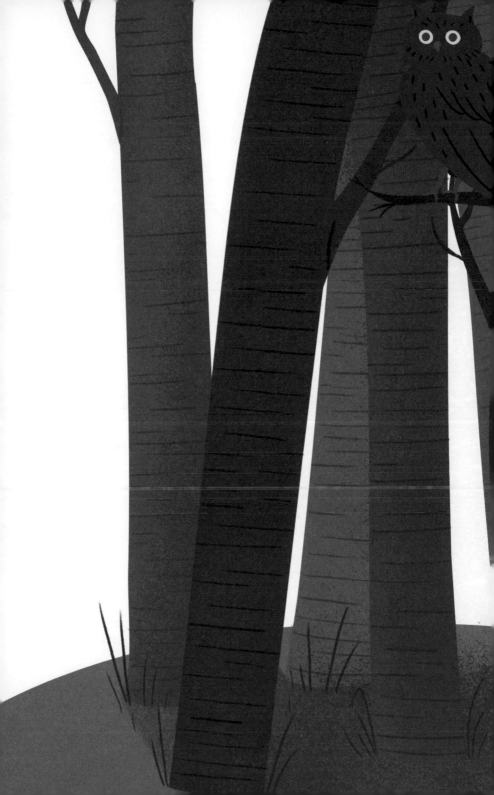

# 38.

During the daytime, trees —along with every other plant—use photosynthesis to make sugars to feed themselves. At night, when photosynthesis stops, they exhale carbon dioxide and water. Go out at night and visit a tree. **Run your fingers over the trunk and leaves. Do they feel damp? How do they smell? Let your senses absorb the experience.**

# 39.

**Draw a tree by night using black and blue pencils.** Leave white areas where the moonlight hits the leaves.

# 40.
·······

Trees create intriguing silhouettes at night, especially in the winter, when the branches are without leaves. **Cut out some winter tree silhouettes from black paper and glue them here. Make the shapes as wild as you can.**

# 41.
·······

Going on a long hike at night is an experience you will never forget. Apart from the fact that it is magical to walk with only the light of the moon and the stars, it can also be scary. The dark forest can feel intimidating, but that might also contribute to the excitement. **Plan a night hike in a natural place that you know and ask a friend to join you.**

## 42.

Some animals are most active during the day;
others are active at night—the nocturnal
animals. However, some animals are active at
dusk and dawn—the crepuscular animals. These
include cats and stray dogs, but also deer,
raccoons, and hares. As soon as dusk arrives,
they come out of their hiding places. This is
the best time to see deer and wild hares out
in the open. If you drive past an open area
near a forest, and there are no cars behind
you, slow down and look around in case you
can see any movement.

## 43.

Not all owls are nocturnal. You can tell by the
color of their eyes which time of day they like
to hunt. If their eyes are yellow, they are active
during the day; orange, at twilight; dark, at
night. **Draw an owl face and decide what color
eyes to give it.**

## 44.

Sometimes we wake up in the night feeling highly creative, bursting with ideas. It's not always a sign of anxiety. If you wake, don't fight it. As long as you can catch up on your sleep the next day, get up, enjoy the nightly flow, and jot down the ideas that come to you.

...........................................................................

...........................................................................

...........................................................................

...........................................................................

## 45.

Something to do at least once in your life is to sleep in a hammock outside on a summer night, or just take a short evening nap before you head to bed. Enjoy the soothing sounds of the wind rustling the leaves of the trees and let yourself drift off into beautiful dreams.

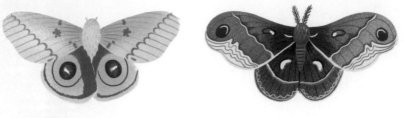

## 46.
......

Anyone who thinks moths are boring is mistaken. Some, such as the Io moth, are so beautiful they easily outshine their sun-loving relatives, the butterflies. **Decorate this moth with a pattern.**

## 47.
......

Take a closer look at the bugs that are out at night. **Which little creatures can you see? Notice their colors and their behavior (and give some their freedom back by separating them from your outdoor lamps).**

...............................................................................

...............................................................................

...............................................................................

...............................................................................

## 48.
......

Plants and nocturnal animals need darkness to do their thing. Don't overdo it with outside lighting, or have none at all; it affects night-time nature more than you might think. If you want outdoor lights, consider subdued colored lighting rather than bright white spotlights.

## 49.
......

Fireflies and glowworms are magical nocturnal phenomena. Adult females glow to attract mates, and the larvae glow to scare predators. Some kinds of fireflies flash to communicate with each other. Each species of light-up bug has its own flash pattern. **Draw some more fireflies to brighten the night.**

Angel's trumpet (*Brugmansia arborea*)

## 50.
.......

Some flowers bloom only at night. In the late evening these "moonflowers" open their—often big and white—majestic petals, releasing intense scents into the air to attract moths and even bats. Usually, they are toxic, such as jimsonweed (also known as datura) and angel's trumpet (which are often confused with each other). But they smell sensational. The honeysuckle is also known to have a more intense scent in the evening to attract moths for pollination. **On a summer's night, take an evening walk and smell the flowers trying to attract the nocturnal insects with their perfume.**

Jimsonweed or Datura (*Datura stramonium*)

## 51.
......

Some botanical gardens open their doors on summer nights so you can see the Amazon water lily, also known as the "Queen of the night," a water lily known for its gigantic leaves. Each of its flowers opens for only a couple of hours two nights in a row. On the first night, the flowers are white and have a pineapple scent. On the second night, they turn pink and hardly smell. Moonflowers have inspired many poets and storytellers over time. **Think of an idea for a story in which moonflowers play a role.**

Amazon water lily or Queen of the night (*Victoria Amazonica*)

## 52.
.......

The moon exerts a force on the earth; that's why we have tides. Research has shown that animals behave differently depending on the intensity of the moonlight. Since the beginning of time, people have assigned spiritual powers to the moon and have even planned their actions with the lunar cycle as their guide. On a night when the moon is bright, go for a meditative walk. **Take long, deep breaths and feel empowered by the moonlight.**

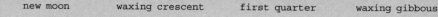

| new moon | waxing crescent | first quarter | waxing gibbous |

## 53.
.......

If you look at the sky at the same time every night, you will find the moon at a different point in the sky and at a different angle. Loosely keep track of the whereabouts of the moon this month in relation to your house. **Where is the moon tonight?**

# 54.

The large dark spots on the moon are cooled-down lava beds, remains from when the moon was still volcanically active. The smaller dark spots are craters from meteor impacts. Did you know we can only see one side of the moon? The same side faces the earth all the time. Take a pair of binoculars outside and have a closer look at the moon. **Draw the dark spots you see on the full moon on this page.**

full moon          waning gibbous          last quarter          waning crescent

# 55.

*Mångata* is the Swedish word for the glimmering, roadlike reflection of the moon on the water. Sweden is the only country that has a word for this beautiful phenomenon. **Draw a *mångata* under the full moon on this page.**

NOCTURNAL NATURE

## 56.

Stargazing gets a lot more interesting if you can identify stars and constellations. In the northern hemisphere, it is easy to recognize the constellation Orion, which looks similar to an hourglass. It is also easy to see Sirius, the brightest star in the sky, sparkling like a disco ball in the constellation of Canis Major ("greater dog"). Each star is a burning ball of gas, like our own sun, sometimes with its own planets orbiting it. **Look up at the night sky and notice the difference in how stars sparkle.**

Orion

## 57.

Can you see any planets tonight? You can tell them apart from stars because they don't twinkle as much. Mars is recognized by its reddish glow. If you have binoculars, you can see the rings on Saturn. Online communities keep track of when and where you can see the planets of our galaxy. **Draw a planet and note when it can be seen.**

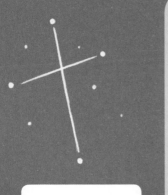

**Southern Cross**

## 58.
. . . . . . .

Before GPS we used the stars to guide us. Polaris, the polestar (North Star), was helpful to sailors because of its position: almost aligned with the earth's northern axis. Looking north, you'll see the other stars circling around it. Polaris is at the end of the constellation Ursa Minor, meaning Little Bear but often called the Little Dipper. The Southern Cross is an important constellation in the southern hemisphere. It is made up of five bright stars in the shape of a cross, a particularly clear and easy-to-recognize pattern. **Try to tell north and south by looking at the stars tonight.**

## 59.
. . . . . . .

The physicist Stephen Hawking said, "Look up to the stars and not down at your feet. Try to make sense of what you see, and wonder about what makes the universe exist. Be curious." Looking at the universe takes your mind off things. **Let your thoughts wander when you look up at the sky. What questions come up?**

**Canis Major**

# 60.
.......

The night has inspired many poets, writers, and musicians. Let yourself be inspired by the night and compose a little poem, or just let your pen write down the feelings you associate with the night. Not a writer? **Search for lyrics and quotes about the night and copy them here.**

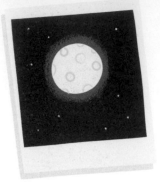

# URBAN NATURE

Life in the city—it's exhausting. Without us
noticing it, our brains are constantly processing
information, from billboards that grab our
attention with their bright colors to constant
sounds that we want to identify. The reason
nature is so restorative is that it only modestly
grabs our attention. As ecologist Ross Cameron
explains: "Nature doesn't need a lot of mental
power. It stimulates, but in a low-key way that
seems to help the brain recuperate." Our brain
gets a break and a chance to reset.

However, nature is not found only in the
countryside. It's the little robin hopping in
front of your house; it's the flowers on the
windowsill and the tree near your parking space.
Luckily, a growing awareness by governments and
city planners means that green developments are

on the increase. More green in city areas not only restores us, but it also improves community relations, makes people more physically active, and just makes people happier and relaxed. A decade-long analysis of a vacant lot greening program in Philadelphia, led by Charles Branas, showed that the effect is not superficial: areas with well-cared-for green plots and community gardens even had reduced levels of crime.

We should fill as many city spaces as possible with plants, trees, and flowers. Not only do they make us happy but they also absorb rainwater, clean the air, and regulate city temperatures in the summer. So let's go out in the city and look for nature. Draw it, investigate it, and appreciate it. But also, let's go plant some more!

# 61.
......

Make nature microbreaks a daily habit. Research at the
University of Melbourne in Australia showed that even a
30-second microbreak looking at a green roof gave subjects a
creativity boost. Do you work next to a window? Make it a routine
that every time you press "send" on an e-mail, you look outside
for at least 30 seconds. It will give your brain a well-deserved
break after a moment of focus. **Draw your window view.**

# 62.
......

It's always possible to have a
brief connection with nature,
even when walking down the
street. For example, look for a
fallen tree leaf. Pick up one that
attracts you in some way, perhaps
a tiny leaf that has fallen off
prematurely or one with beautiful
colors. **Draw or paste it onto
this page.**

## 63.

According to research, naturalistic garden styles are a highly restorative, stress-relieving form of landscape, especially when they include flowering plants. Locate a nice natural plot in your area that you can visit. **Describe it in a few words.**

....................................................................

....................................................................

....................................................................

....................................................................

....................................................................

....................................................................

....................................................................

....................................................................

## 64.

Not enough flowers in your neighborhood? Make a "flower bomb." Use a 1:1 ratio of soil mix or compost and dry organic clay (also used for face masks), along with some seeds of native wild flowers. Mix them together and add water to get the right consistency to form the mixture into balls. Let them dry for a couple of days, and then throw them where you want more flowers to appear.

## 65.

Nature has always been and will always be a source of inspiration for artists and designers. Thanks to this, we can enjoy a spark of nature even when we are in the midst of a busy city. Look for nature patterns in the designs you encounter today: in architecture, in fabrics, in cutlery, in furniture. **Make a list of the patterns you see.**

.................................................................................................................

.................................................................................................................

.................................................................................................................

.................................................................................................................

.................................................................................................................

.................................................................................................................

.................................................................................................................

## 66.

Beethoven loved spending time in his garden and out in nature. He wrote, "The woods, the trees and the rocks give man the resonance he needs." **Listen to a piece of classical music inspired by nature, such as Beethoven's "Moonlight Sonata" or "The Four Seasons" by Vivaldi.**

## 67.

Restore the wonderment that is so easily lost in the hustle and bustle of our busy lives. Look at a natural object in your urban surroundings and open your mind and your heart. Wonder about something. **What questions come to mind?**

......................................................................................................

......................................................................................................

......................................................................................................

......................................................................................................

......................................................................................................

......................................................................................................

......................................................................................................

## 68.

Many of the objects we use in daily life are based on things we have learned from nature. Inventing things by looking at nature is called biomimicry. Swimsuits that were inspired by sharkskin, for example, made Olympic swimmers so fast that the suits were banned. Look at nature and animals with the eyes of a "biomimic." **What principle or process would you copy if you could?**

......................................................................................................

......................................................................................................

......................................................................................................

......................................................................................................

......................................................................................................

......................................................................................................

......................................................................................................

......................................................................................................

# 69.
.......

Some of the plants we consider annoying
weeds are actually really important.
The stinging nettle, for example, acts
as a nursery for many species of
butterfly,which lay their eggs on the
plant. And the dandelion provides food
for caterpillars of many moths. Put
your gloves on and look for signs of
caterpillars on stinging nettles or
other plants. Check whether you can see
a silk tent among the leaves, built by
caterpillars for protection. **Draw nettles
or dandelions for the butterflies on this
page, with their leaves and stems covered
by veins and hairs.**

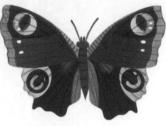

Peacock
(*Aglais io*)

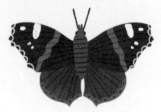

Red Admiral
(*Vanessa atalanta*)

Swallowtail
(*Papilio machaon*)

# 70.
.......

Dandelions and stinging
nettles are also healthy
ingredients in the kitchen.
Add nettles or dandelion
leaves to a stirfry or
omelet. Wear gloves while
picking nettles and wash
all leaves thoroughly
before using them.

## 71.

Goutweed (ground elder) is an invasive weed —it will take over the whole backyard. The good news is that you can eat it! The young leaves (which appear before the plant has flowered) not only taste good but were also used by the Romans to treat gout and arthritis. **Make a pesto by blending together 2 ⅔ cups (80 g) of thoroughly washed goutweed leaves, ½ cup (50 g) of pine nuts, ½ cup (50 g) of Parmesan, ⅔ cup (150 ml) of olive oil, and two garlic cloves.**

## 72.

Look for a wild flower that's growing through a crack in the patio. **Draw it or take a photograph. What is the name of this flower?**

## 73.

You can find the delightful common daisy growing on almost every lawn. Daisies used to be named woundwort, or bruisewort, because of their alleged healing powers. When applied externally, they have an antiseptic and anti-inflammatory effect on wounds. The flowers also encourage blood flow to help heal bruises. **Look for a common daisy and paste one here.**

## 74.
........

City trees are strong trees and they are important to the environment. They improve air quality, cool down the streets, regulate water flow, reduce carbon emissions, lift the spirits of city people—the list goes on and on. Find a big city tree. Smell it. Guess its age. Some trees are so old they have seen the city without cars, before it was even a city. Place your hand on the tree and wonder about everything it has seen. **Write down what comes to mind.**

..................................................

..................................................

..................................................

..................................................

..................................................

..................................................

..................................................

## 75.
........

Platanus, or the plane tree, is a favorite city tree not only because it is beautiful but also because of its insensitivity to pollution. The tree lets go of old and damaged bark. That's why the trunk is a fascinating patchwork of white, taupe, beige, and brown spots. **Meditate for ten minutes, calmly breathing in and out. Imagine you can let go of negative thoughts like a plane tree loses its bark.**

## 76.

The ginkgo biloba doesn't mind city pollution and extreme weather. It's referred to as a "living fossil" because fossilized ginkgo leaves have been found dating back 250 million years. The oldest living ginkgo is in China and is 3,500 years old. Many people love the tree because of its fan-shape leaves, which turn a deep shade of yellow in fall. **Draw a pattern made up of ginkgo leaves.**

## 77.

Which trees are the most common where you live? **Find out the names of some beautiful trees in your city.**

## 78.

Even in the midst of a busy city, you can find moss growing, like tiny green oases in a concrete desert. Some kinds of moss look like a miniature forest when you observe them with a magnifying glass. **Find different types of mossy landscapes today. Draw one of them.**

## 79.

People feel less benefit from a natural area where there is a lot of litter. Is the park near your house swarming with plastic waste? Then organize a neighborhood cleanup! It has three benefits: you'll enjoy a cleaner environment (at least for a while); physical activity for the community will leave you feeling satisfied and content, especially as it's an outdoor activity; plus, it will foster positive relationships with your neighbors. **Note your plans and ideas here.**

........................................................................................

........................................................................................

........................................................................................

........................................................................................

## 80.

What might look at first like a boring overgrowth of neglected plants alongside a road can become something much more interesting when you take a closer look. Focus on a piece of nature you would usually pass by without noticing. Find something about it that intrigues you. **Take a photograph of it or draw it.**

## 81.

Even if we feel removed from nature because we are surrounded by brick and concrete, the sky is always there. **Take a sky-watching break today and draw what you see above the rooftops.**

## 82.

Lavender and rosemary keep their scent long after they're dried. Dry fresh herbs by hanging them upside down tied with string. You can also keep them in a pocket made of cheesecloth or muslin in your closet or under your pillow. A house that smells of natural herbs is not only pleasant but also calming for the mind.

## 83.

Surround yourself with natural fabrics. A good wool sweater or rug has a kind of nostalgic comfort that seems extra soothing. The same goes for soap made with natural ingredients. They're all "old friends" that comfort us. **Make a little list of natural products you like to have around you.**

# 84.

A lot of animals live in the city—more than you think. They're sometimes seen as a nuisance, but with humans taking up more and more space, they have had to adapt. Helping urban wildlife will lift your spirits and help you reconnect with nature. You could do the following:

* In dry spells, place shallow bowls of water on the ground for bees and small animals.

* Help toads and frogs cross roads during the mating season by signing up as a patroller.

* Make a peanut string for birds in winter.

* Make animal passages in yard fences.

* Get rid of concrete paving and plant flowers.

# 85.

Most city animals are crepuscular, which means they are most active in the twilight hours. Go out to a park or your yard to look for animals. If you can't see any, sit still and listen carefully. Rustling in the bushes might indicate animal activity. **Make notes about what you see or hear.**

## 86.

You might not think it, but cities are unexpected havens for birdwatchers. Berlin has the largest urban population of goshawks in the world, and in Central Park, in New York City, you can see some rare birds, especially during migration season. Look for birdlife in your hometown. They may be nesting on chimneys or swooping through the trees in parks. Watch a big tree to see which birds fly in and out of its branches. **Note the birds you see or hear.**

.................................................................................................................................

.................................................................................................................................

.................................................................................................................................

.................................................................................................................................

## 87.

Keep an eye open for loose feathers on the ground. **If you find one, paste it here or draw it.**

## 88.

Birdsong can be mesmerizing, and becoming familiar with different songs, and knowing which bird you are hearing, makes listening even more fun. The wood thrush and song thrush, for example, are both noted for singing distinct songs in the evenings in loud, clear notes. **Draw a little city bird.**

## 89.

Take your daily break outside today. Bring a cup, thermos, or flask filled with your favorite brew. Drink it somewhere outdoors, preferably underneath trees. **Drink it mindfully and notice the nature around you.**

## 90.

When we pet a friendly animal, our blood pressure goes down. And when dogs and humans gaze into each other's eyes, something else remarkable happens. Researchers have found that mutual gazing increases levels of oxytocin—a hormone associated with feelings of love and tenderness—in both parties. **Write about what you feel when interacting with a house pet.**

..............................................................................

..............................................................................

..............................................................................

..............................................................................

..............................................................................

## 91.

Cats: They will always have a mind of their own. They sleep most of the day and night, and they purr when fussed over or petted. But in the twilight hours, they like to hunt, just like wild cats. **Observe a cat in your house or neighborhood and make notes about its behavior.**

..............................................................................

..............................................................................

..............................................................................

..............................................................................

..............................................................

..............................................................

..............................................................

# 92.
.......

The more nature you can experience in your yard, the better.
If you don't have much space, grow upward. Plant a native ivy
or clematis to climb up a wall, fence, or balcony. Its flowers
will provide food for tons of insects and bees. The insects
will attract small birds. You will bring life to the bricks and
stones, help to clean the air of pollution, and add color to
your surroundings. **Draw a plant climbing up this page.**

# IN THE FOREST

When was the last time you were wandering deep in a forest, with the sunlight dripping through the foliage, the woody fragrances, the frantic singing of birds, and maybe the rustling of a deer in the undergrowth?

This immersive kind of nature experience is essential, according to nature researcher Tim Beatley, who developed the "Nature Pyramid." On the bottom level of the pyramid is the nature we need every day, such as a stroll in a city park or watching a bird. In the middle are regular visits to larger, more remote parks. And at the top of the pyramid are trips to natural areas such as forests, "where immersion is possible," and which we need at least once a year. Those trips at the top are important and enriching, with lasting health benefits.

The problem is that because we are so cut off from nature, we experience something called "nature knowledge deficit." We don't understand as much about the natural environment as we used to, which leads to less appreciation of it. When you don't feel at ease in nature, it will not be as therapeutic for you, and the thought of going on such a trip is less alluring. To enjoy nature more, we need to understand it better.

This chapter is about reconnecting with the deep forest. We're going to activate our inner ranger and look for animal signs, identify trees, and learn what Japanese researchers discovered about the smells of the forest. And we're going to connect with the mystical forest, because, if anything, the deep forest is also a place to dream and let your mind meander.

## 93.

It's nice to walk with a stick, and there are plenty to be found in the forest. Find one and decorate it by carving it with a pocketknife (only if you know how to use one), or make it really smooth by removing the bark. You can also decorate your stick in other ways, perhaps by winding colored twine around it, and maybe adding feathers or some leaves that you've found.

## 94.

The needles of a Douglas fir tree, if rubbed between your fingers, release an odor that resembles candied orange peel. Oak bark smells of tannin. Look for a twig on the ground or peel a piece of bark from a tree. Break it in half and inhale a couple of times to catch the fragrance. **Describe the scents as if you were tasting wine.**

..........................................................................................................

..........................................................................................................

..........................................................................................................

..........................................................................................................

## 95.

There are more ways to identify trees than just by looking at them. The fresh branches of spruce, for example, taste a little like citrus. You can also chew on the branches of oak and poplar. **Can you taste the differences?**

## 96.

Trees in the forest have a way of spreading their branches in the sky, so they protect the earth from drying out because of sunlight. The result is a beautiful crochetlike blanket of green over our heads, with golden sunrays filtering through. The Japanese have a particular word for sunshine that filters through the leaves of trees: *komorebi*. Look up and see how the tree branches spread. **Take a photograph to capture it.**

## 97.

When it's cold, hot chocolate is the perfect drink for a long walk in the forest, especially when you are with kids. Research shows that a natural environment intensifies your sense of taste. **Bring some already made hot chocolate in a thermos or warm it on the spot with a small camping stove.**

Gray Birch
(*Betula populifolia*)

Larch
(*Larix*)

Spruce
(*Picea*)

Hornbeam
(*Carpinus betulus*)

Beech
(*Fagus sylvatica*)

Ash
(*Fraxinus excelsior*)

Poplar
(*Populus*)

Willow
(*Salix*)

Linden
(*Tilia*)

## 98.

Knowing what kind of tree you're looking at intensifies the joy of being in the forest. It's a simple way to escape from your thoughts and focus on something outside of yourself. **Look around you and see which trees you can recognize.**

Pine
(*Pinus*)

Holly
(*Ilex*)

Maple
(*Acer rubrum*)

Loblolly pine
(*Pinus taeda*)

Sweet gum
(*Liquidambar styracifula*)

Douglas fir
(*Pseudotsuga menziesii*)

Aspen
(*Populus tremuloides*)

Dogwood
(*Cornus florida*)

Oak
(*Quercus*)

Cypress
(*Cupressus*)

## 99.
. . . . . . .

Collect leaves from a couple of different trees. Try to look at them without labeling them. Hold them up to the sunlight and see the difference in how the sunlight shines through them. Notice their different colors and delicate nerves. **Smell the leaves and feel their structure with your fingertips.**

IN THE FOREST

## 100.

Trees are home to many animals and plants. It's not just a tree you're looking at—it's an apartment building. Look at a big old tree and try to see what life-forms it shelters. **Write down what signs you see that indicate animal activity.**

...................................................................................................

...................................................................................................

...................................................................................................

...................................................................................................

...................................................................................................

...................................................................................................

## 101.

Even when trees fall over, they sometimes continue growing. Look for a big fallen tree and climb onto it. Sit on one of its branches. Be still and become one with your surroundings. **Make a little sketch of your view while perching on the tree.**

## 102.

Paste some leaves you've found onto these pages and have fun making them come to life by drawing on legs and arms, or even gluing on eyes and hats made from whatever you can find.

## 103.

Around each big tree, there are many "baby" trees of the same kind waiting to grow. When the big tree dies, and the sunlight finally reaches the offspring, they can grow into big trees.
**Look for the baby trees around a big tree.**

# 104.

No two tree trunks are the same. Some are overgrown with mosses; some have weird bulges. Some tree barks have amazing patterns, colors, and textures. Notice how tree trunks are decorated by nature. **Draw some of them here.**

## 105.

Trees are social creatures, according to Peter Wohlleben, a famous German ranger and researcher. Trees help each other through their roots, supplying struggling trees with nutrients or warning each other by spreading special gases when they are being attacked by parasites. They can be altruistic, helping other trees without any benefit for themselves. **Walk through the forest thinking about how the trees that surround you are communicating with each other.**

## 106.

Even in the darkest woods, you can find flowers, such as the sugarstick, named for its resemblance to a peppermint stick candy. Instead of using photosynthesis to get energy, it draws energy from fungi, which in turn draw energy from the roots of trees. Most forest flowers are to be found alongside streams in springtime when the trees are still bare. **Draw a forest flower.**

## 107.

The smells of the forest contribute to the well-being of humans—on an emotional level as well as on a chemical level. Qing Li, president of the Japanese Society of Forest Therapy, has found that "pleasant tree smells," also called phytoncides, boost the immune system and lower blood pressure. The essential oils transmitted by evergreens, such as the cypress tree, turned out to be especially effective. **What is your favorite forest scent?**

.................................................................................................

.................................................................................................

.................................................................................................

.................................................................................................

.................................................................................................

.................................................................................................

.................................................................................................

## 108.

Here is a breathing exercise to inhale the scents of the forest. **Stand in an upright position and relax your shoulders. Breathe in for six seconds, then breathe out for six seconds. Repeat this for one minute.**

## 109.

The scent of cypress in your bedroom will improve your sleep and help you feel more rested the next day. It's best to use a diffuser with cypress oil. Look for a cypress tree and bring a little twig home. **Draw it here.**

## 110.

The young shoots of the spruce and the leaves of the birch can be used to make an aromatic forest tea. Herbalists and practitioners of natural medicine consider the birch, dandelion, and stinging nettle as the top-three detoxifiers. Tea made from willow bark can reduce a headache and was used by our ancestors as the precursor of aspirin.

## 111.

Different trees make different sounds: such as when the wind moves the leaves and branches or the sound when you knock on the tree. Experience the forest by focusing on only what you hear. **Note the different sounds.**

...................................................................

...................................................................

...................................................................

...................................................................

...................................................................

...................................................................

## 112.

Going on a camping trip with a tent is probably the best way to get close to nature. **Draw a little camping scene and recall or imagine a camping trip.**

## 113.

When setting up camp, it is handy to be able to tell where the sun will set and rise. You don't need a compass; you only need the sun. Put a stick in the ground in a spot that the sun's light will reach for at least 15 minutes. See where the stick casts a shadow and mark the end with a pebble. Wait 15 minutes and put another stone on the end of the new shadow. Draw a straight line between the two rocks. This is a rough east-west line, with the first pebble pointing to the west and the second pebble to the east.

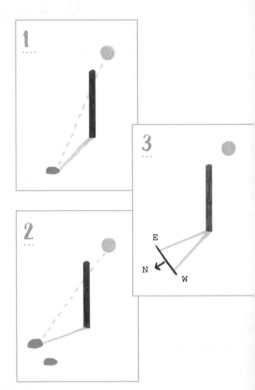

## 114.

For our ancestors, the forest was one big salad bar. In springtime or early summer, you can make a forest salad with the buds and young leaves of beech; in fall, you can eat its nuts. Never eat anything if you don't know what it is in case it is poisonous. **Make notes and drawings of edible forest plants.**

...........................................................

...........................................................

...........................................................

...........................................................

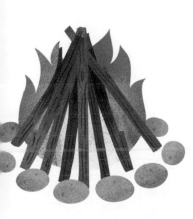

## 115.

As long as the forest you are in is not experiencing a dry period, you might be allowed to make a fire (check first). A campfire is a huge happiness booster, and everything tastes better when cooked outside over a fire. Start by digging a hole about 6 inches (15 cm) deep. Make a circle around it with stones to contain the fire. Place dried leaves, pine needles, and small twigs in the middle. Build a tepee over it using twigs and sticks, leaving enough space for air to get through. Set it alight and, once it's a decent size, place bigger logs on the fire.

## 116.

Add some sage leaves to your campfire to keep mosquitoes away.

## 117.

An exciting way to enjoy the wild is to look for signs of animals. Act like a ranger and make field observations. Search near water, in particular, and along smaller side trails. Look for droppings, nests, eggs, feathers, scratch marks, and signs of feeding, such as empty snail shells or piles of seed pods. **Record your observations by drawing or writing here.**

## 118.

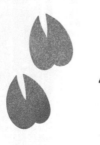

Animal prints can be found in wet or moist areas, especially near mud puddles and streams. You can also spread a light covering of flour over the ground, and come back the next day to see if there has been any animal activity. **Draw an animal footprint.**

## 119.

People make trails in the forest, but animals have their own little routes through the trees, too. If you know what to look for, you'll see them. Look for tunnels in undergrowth and paths worn in meadows. **If you suspect a path, look for hair and claw marks on trunks and logs.**

| Deer | Fox | Skunk | Raccoon |

## 120.

Aside from footprints, another way to detect animals is by their scat or droppings. Scats are often used by animals to mark their territory, so they're easy to find. Note that while domestic dog scat is mealy; the scat of wild canines (for example, foxes or coyotes) will be made up of hair or fruit seeds.

## 121.
.......

In many cultures and nature religions,
the forest is more than a collection of
trees and animals; it's a sacred place,
full of spirituality. The indigenous
people of the tropical rain forests of
Papua New Guinea believe that the dead
linger in the forest, unreachable for
humans, but not for birds. They think
that birds operate as messengers between
the living and the spirits of the dead.
**Listen to the birds singing and let
your mind contemplate the possibility
that they are voices telling you things.**

**122.**
..........

Draw or paint a tropical
bird in this rain
forest. Make it as
colorful as you can.

## 123.

A large forest can feel a little uneasy sometimes, and that's when it sparks our imagination. What creatures do we share the forest with? In Germanic mythology, you will find elves and gnomes. In Iceland, you'll find the *huldufólk*, the "hidden folk." Let your fantasies run wild and look for signs among the trees that you could interpret as the activity of elves and gnomes. **Note any signs that you see here.**

.......................................................................................................

.......................................................................................................

.......................................................................................................

.......................................................................................................

.......................................................................................................

## 124.

Shamans believe that all natural objects have a spirit. They also think that every human being has one or more spirit animals to protect them, help them, and guide them during dreams. **What animal do you feel most connected with and why?**

.......................................................................................................

.......................................................................................................

.......................................................................................................

.......................................................................................................

.......................................................................................................

.......................................................................................................

# 125.

Trees can live to be hundreds of years old. Most trees were here long before us and will outlive us by many years. Many nature religions worship trees as if they are the abodes of spirits. All over the world, people have developed worshiping rituals for trees. Think of an old tree you have a soft spot for, maybe because it's been there all your life or perhaps because it has given you shelter from the sun or rain on occasions. **Draw it here. Think of your own little ritual to thank it, maybe by decorating it with flowers or a garland for a day, or by writing a poem about it.**

## 126.
·······

We are used to so many incentives and instant amusement that
the thought of nature is boring to a lot of us, especially to
kids. Nature's power is fascinating, but not in the in-your-
face, ready-made way we're used to. But that's precisely the
reason why our kids should be out in nature more. Research
says that a natural play environment stimulates more varied
and creative play behavior. It also helps young children
develop better motor skills and balance. But how do you get
them to go outside? A golden tip from a friend was not to
expect them to like long walks, and also never to say: "Let's
go for a walk." Instead, make it sound like an adventure.
Let them discover things on their own, let them climb hills,
let them get dirty and play with mud. Think about when you
were a child: What made a forest trip a success for you?
**Note what you liked doing in nature.**

....................................................................................................................

....................................................................................................................

....................................................................................................................

....................................................................................................................

....................................................................................................................

....................................................................................................................

....................................................................................................................

....................................................................................................................

**127.**

**Build a hut.** Making a hut with fallen branches is already plenty of fun, but what if you bring some rope and add a piece of fabric, such as an old tablecloth, to the game? Come prepared for more fun.

## 128.
. . . . . . . .

For a fun outdoor game, find a place
in the forest with a few trees around
a clearing, without too much scrub and
undergrowth. One person stands in the
middle, the others each touch a tree.
When everyone changes trees, the middle
person tries to tag someone.

## 129.
. . . . . . . . .

Build a tower with tree
branches you find lying
around. How high can you
make it?

## 130.
.........

Make imprints of different tree barks
with wax crayons. When you compare them
afterward, can you guess which print
belongs to which tree?

## 131.
.........

It's okay to be bored sometimes.
At first it's uncomfortable, but
then the ideas start flooding
in. In these overscheduled
days, boredom is a necessity.
Kids need it to grow. Boredom
fosters creativity, drive,
and independence.

# EARTH'S COLORS

One of the most magical phenomena of nature is color. Would nature be as interesting if it wasn't for all the colors in it? In nature, colors are there to attract or warn or hide, and by doing that, amazing things happen. "Colors are the smiles of nature," wrote the English poet Leigh Hunt. I will never forget a diving trip at a coral reef, where I saw fish in such bright colors they looked as if they were on their way to a glam-rock party.

Sometimes I'm jealous of the bee and the butterfly, because their eyes have four color-receptor cones (ours have three), and they can see many more colors than we can, including ultraviolet colors. But even for humans, there is a lot more to see, if you pay attention. Because colors change depending on the light,

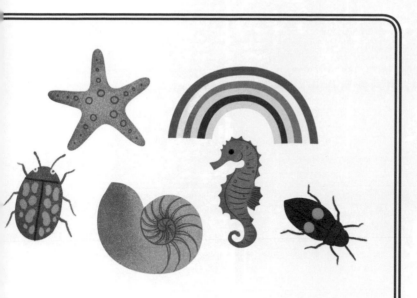

they are the magic show that never does the same
trick twice. If we take a moment to switch off
the automatic pilot we use in hectic times, a
new world opens. What do we see if we let go of
how we think things should look? What would we
know if we didn't have set words, such as yellow
and red, to describe colors?

In this chapter, we take a closer look at all
those bright hues that color our world: the
rainbows, the sky when the sun sets and rises,
and, of course, flowers and how they communicate
to attract pollinators. Not forgetting the
beautiful patterns of animals. Also, we'll be
paying attention to how colors affect our minds,
because we might sometimes forget, with our
smart ideas and savvy inventions, but we too are
nature. Always have been, and always will be.

# 132.

A rainbow is magic in the sky. Rainbows occur when the air is filled with droplets that split the sun's rays into separate colors, appearing in the shape of an arch. If you're lucky, you can see the whole color spectrum from red to violet. If you're doubly lucky, you might see a double rainbow: a slightly larger arch appearing above the inner rainbow with the order of the colors reversed. **When was the last time you saw a rainbow? How did it make you feel?**

..............................................................................................................................................

..............................................................................................................................................

..............................................................................................................................................

..............................................................................................................................................

..............................................................................................................................................

..............................................................................................................................................

# 133.

You can find rainbows everywhere, even in the spray created by waves or in the mist coming from a waterfall. You can also make your own rainbow! **Create a mist in the air with a spray bottle, turning it so that the water catches the sunlight. Which colors do you see?**

.............................................................

.............................................................

.............................................................

.............................................................

.............................................................

# 134.

Why stick to the basic colors? **Draw a rainbow with any of your favorite shades.**

# 135.

Color is a visible form of energy created by light at different wavelengths and frequencies. That's why some people believe that we not only see colors, but can also feel them. **Fill this space with a color you're drawn to right now. Focus on this color for a couple of minutes, while breathing in and out slowly, and notice how it makes you feel.**

# 136.

Not all languages have the same basic color categories. Some cultures only name three colors (light, dark, red); some five. It's not that those cultures don't see the same colors; they just label them differently. In some languages, blue is called sky and brown would be something like mud, because that's what they resemble. **Describe the colors around you without using the usual terms for them, but using the words for natural phenomena instead.**

........................................................

........................................................

........................................................

........................................................

........................................................

........................................................

........................................................

........................................................

........................................................

........................................................

## 137.

A sunset will never lose the power to give people a feeling of awe: the grandness of it, the magical colors, the connection with time passing and days ending. **Think of moments when you've witnessed a beautiful sunset.**

## 138.

In summer, when it's been really hot all day, sunset is the nicest time to be active outside. Go for a run or a walk in the evening. See how the trees catch the last sunrays. Enjoy the cooling down of the earth while you take deep breaths.

## 139.

The leaves of a tree can appear pure gold at sunset or silver in the morning light. **Draw a branch with its leaves glowing in the evening light.**

# 140.

Why is the sky sometimes purple? Why is it sometimes pink? When the sun is low, it's at a steep angle and the sunlight has to cross a lot of the earth's atmosphere before it reaches us. Only the colors with long wavelengths, such as red and orange, can make it. The blue is mostly scattered away. If the sky looks purple or pink, it's because of the contrast between the red glow and the scattered blue. **Fill these boxes with little drawings of the sunsets you see over the next few days, and add a few words to describe the circumstances and feelings you had.**

## 141.
.......

Humans perceive green as a
neutral color, and that's
why it's relaxing for us to
see. It's even been shown
to improve reading ability
and creativity. Go for a walk
in a nearby park and notice all
the different shades of green.
**Note how you feel before and
after your walk.**

........................................................................................................

........................................................................................................

........................................................................................................

........................................................................................................

........................................................................................................

........................................................................................................

........................................................................................................

........................................................................................................

## 142.
.......

Even looking at a painting or
photograph of green scenery
can lower your blood pressure.
**Collect images to make a
hidden nature mood board
inside a kitchen cabinet.
Every time you open it,
it will lift your spirits.**

# 143.

Use paint to mix as many different shades of green as you can. To make green, combine yellow and blue paint. When you think about it, that's interesting, because sun (yellow) and water (blue) is also what makes green plants grow. **Vary the amount of blue and yellow and add other colors to create even more shades of green, or throw a little white or black into the mix to make it lighter or darker.**

EARTH'S COLORS

## 144.

"The earth laughs in flowers," said the American philosopher Ralph Waldo Emerson. Did you know that flowers have the power to make you feel better? Research carried out by the American Society for Horticultural Science found that patients surrounded by flowers needed fewer painkillers and were in a more positive mood than those in rooms with no plants. They also had lower blood pressure and were less anxious and tired. **Go out and buy yourself a small bouquet of flowers, because they are worth every cent.**

# 145.

Every flower has its own way to attract pollinators, such as bees and butterflies. Some make themselves beautiful, some smell sweet, and some are picky and only release their pollen when a honeybee makes a specific sound. Think about what flowers you like and what they say about you. **Do you love wild orchids or the more modest daisy?**

## 146.

*Lamprocapnos spectabilis* is a flower in the shape of a heart with a little teardrop shape underneath it. After it blooms, it breaks in half. The English common name for the flower is bleeding heart. In Dutch, it's called the broken heart or weeping heart. The name of a flower says a lot about how it is perceived. "Dandelion," for example, actually means "lion's teeth." The plant was named after its leaves, which resemble sharp teeth. **Find a flower and come up with a new name for it.**

## 147.

The petals of a flower may already have bright colors, but when the sunlight passes through them the purest of colors may be seen. **Hold a flower up so you can see the sunlight passing through its petals.**

## 148.
. . . . . . . .

Some plants produce single
flowers; others produce flowers
in clusters. Take, for example,
the lantana, also known as
yellow sage; the outer flowers
are red (or sometimes pink) and
the middle flowers are yellow.
Because of this, the plant is
also known as the Spanish flag.
Take a closer look at the blooms
in your yard or a local park and
see if they consist of one or
many flowers. **Draw a flowerhead
that appeals to you.**

## 149.
. . . . . . . .

Perhaps the showiest flower of all
is the orchid. Some species don't
even look real. The bee orchid, for
example, is dressed up as a female
bee to attract male pollinators.
It also feels like a female bee,
because it's covered with soft
hairs. **Draw an imaginary orchid.**

## 150.

Go out on a color hunt. Find natural objects that match the colors shown on this page. **Draw or glue them next to their corresponding colors.**

## 151.

When it comes to flower petals, there is a lot more going on than we humans can see. Butterflies and bees are guided to the pollen inside by ultraviolet stripes on the petals like lights on a runway. Green, on the other hand, is not useful to the insects, so they perceive it as gray. **Look at a flower and imagine you can see those stripes. What don't we see?**

# 152.
.........

Use flowerheads or leaves in different shapes to make a pattern. Cover them with a thick layer of paint and stamp them gently on the page. You can also use bark, nuts, or anything else you find to create a nature stamp.

# 153.
........

Insects can have amazing patterns.
These are mostly to warn predators,
with bright colors announcing that
the bugs are toxic or will sting when
attacked. **Draw some more colorful
bugs to add to this collection.**

# 154.
........

Some insects hide by trying to look
exactly like their surroundings.
Go on an expedition in the yard for
beetles and other bugs that try to
blend in. Look closely at plants,
turn over leaves, and inspect stems.
**Make simple sketches of any bugs that
you find and note how they camouflage
themselves.**

...............................................................................

...............................................................................

...............................................................................

...............................................................................

...............................................................................

...............................................................................

...............................................................................

...............................................................................

## 155.

Did you know that the full moon makes scorpions glow in the dark? Scorpions are nocturnal animals, and they don't like light at all. Scientists don't yet know why they light up in the glow of the full moon. But it's good to know you can easily see scorpions in your yard in a full moon.

## 156.

Most people find snakes pretty scary, and no wonder: it's a fear that's been hardwired into us through evolution. But have you ever looked at a snake's skin properly? The colors and patterns can be spectacular. (Remember never to approach any snake unless you are sure it is not venomous.) **Draw a snake with colorful skin.**

## 157.
Create an animal-friendly butterfly collection with butterflies cut from colored paper. **Attach them to this page.**

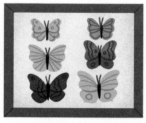

## 158.

Coral reef fish have bright colors to attract mates, repel rivals, hide from predators, and also to recognize each other, researchers have found. Most coral reef fish have colors we humans cannot even see. **Draw a coral reef fish you would like to see.**

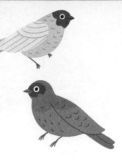

## 159.
.........

Look for colorful birds. Take a tip from birdwatchers and use decent binoculars; it makes a lot of difference. There are also some good birdwatching apps you can use to identify what bird you are looking at. **Draw a bird that you see today.**

## 160.
.........

The stripes of a tiger or a zebra might not look like camouflage, but in the high grasses of the savanna, the stripes make them hard to see. It's also thought that a zebra's stripes might help regulate its body temperature. **Draw a close-up of any skins or fur that you find beautiful or interesting.**

# 161.
........

Make a collage from pictures of
animals, insects, and flowers with
beautiful colors.

# GROWING

I once saw a time-lapse video of a seed growing into a pumpkin. From a tiny seed it became a seedling, growing leaf by leaf into a big plant. Then it developed yellow flowers, and finally a small green oval growing under the flowers gained in size and turned into a big orange pumpkin. It took 108 days. The time-lapse clip lasted almost five minutes and it was one of the most fascinating things I'd ever seen. I watched it twice in a row.

Why was I so fascinated by it? I wondered. I think it's because we don't actually see nature grow. It appears to stand still, but then the next day, or a couple of days later, it's completely different from before. You never see the grass growing, but nevertheless we have to cut it regularly. To see it happening in a

time-lapse video felt like a glimpse into Mother Nature's factory. The way the leaves shaped and spiraled around the stem to catch the maximum amount of sun; the way flowers bloomed and after that made way for the fruit to grow.

Not only was it fascinating, it was also calming to watch. In the twenty-first century, everything moves fast. Research shows that we've started to walk faster; we even eat faster. We're expecting immediate answers and solutions, and we get agitated or worried if someone doesn't reply to a text quickly enough. We're always in a rush. But does it help us? To realize that it takes a seed 108 days to grow into a pumpkin is grounding. As the famous Lao Tzu quote goes: "Nature does not hurry; yet everything is accomplished."

## 162.

Although it may look as if nothing's happening, everything in nature is constantly changing. The grass is growing. Leaves are growing. Seeds are sprouting. It's happening slowly, too slowly for us to see, but it's happening. **Find a place in nature to sit for a while. Be still and think of everything that is happening that you're not able to see.**

## 163.

A lot of plants use other plants as support to grow, because they lack a sturdy stem. Sometimes they help the host plant by sharing glucose. Sometimes a plant suffocates its host. Just like human relations, these relationships can be supportive or stifling. **Think about the people close to you. Who gives you energy and who can be a bit draining?**

................................................................................

................................................................................

................................................................................

................................................................................

................................................................................

................................................................................

................................................................................

## 164.
. . . . . . . .

Trees or shrubs that look as if they're dying can grow
new branches when you least expect it. When one of
your garden plants looks like it's dying, cut off all
the brown leaves; it might just come up again. **Draw
some more branches and leaves on this plant.**

## 165.
. . . . . . . .

Most ornamental plants—
geraniums for example, or
roses—make more flowers when
the wilted ones fall off.
Removing the dead flowers by
hand can be a relaxing task.
**Calm your mind by focusing on
only the plant, the flowers,
and your hand.**

## 166.

How do you count the age rings
inside a tree trunk? An annual ring
is composed of spring wood cells
and summer wood cells. With oaks,
hickories, elms, and ashes, you
can easily see the difference; the
spring ring is light and wide, while
the summer ring is thin and dark.
Together, these two rings count for
one year. **Look for a tree stump and
count the rings. How old is the tree?**

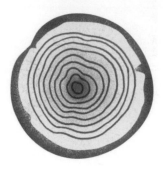

## 167.

Because of the lack of sunlight, young
trees grow slowly in the dense forest.
But that's a good thing. Due to the
slow growth, they are extra resistant
to fungi and breakage by the wind. A
beech tree that looks young can actually
be 80 years old. A mature beech can be
200 years old! So, for a tree, old age
is relative. **Imagine you could grow to
be 200 years old. Would you want that?
What's the reason for your answer?**

## 168.

Many animals undergo a complete transformation
when they grow older. We all know the story
of the ugly little duckling that turned into
a swan. The pups of harp seals and penguins
look like fluffy toys. **Draw an infant animal
with loads of hair, such as a cub, a chick,
or a duckling.**

## 169.

"To plant a garden is to believe in
tomorrow," said the actress Audrey
Hepburn. Collect some (not all) seeds
from a wilted flower and keep them in a
paper bag in a dry place. Label it, so
you remember what you collected. You
can exchange seeds with friends and
neighbors or give them away as presents.
**Note here which seeds you found and
where you found them.**

## 170.

One of the wonders of nature is the way that things grow. A nautilus shell spirals in precisely the same way as a tornado—a logarithmic spiral. Even without knowing the math, it's fascinating to recognize the same shapes in different things. **Look for more spirals in nature and draw one.**

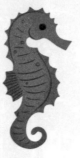

## 171.

Part of the sea horse mating process is a dance in which the female and male spiral upward, snout to snout. The female transfers her eggs to the male, who will carry them until birth. **Draw a mate for this sea horse.**

## 172.

One reason that looking at nature is so relaxing is because of nature's fractals—the constant repetition of shapes at different scales, such as the way that the form of a tree repeats itself in the branches and the lateral branches. You can also find fractals in leaves. **Look for fractals in nature. Where can you see them?**

# 173.

Nature's repeating shapes inspire a lot of design: wallpaper, for example, or tiles. **Fill this page with an abstract design inspired by the geometry of nature. This could be spirals, fractals, anything you like.**

**174.**

There is so much love to be found in nature. Investigate the most romantic of flowers: the rose. Look at the way the rose petals grow around the core. Can you see a pattern? How many leaves can you count? **Glue rose petals on this page in a heart shape.**

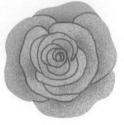

**175.**

Many leaves grow in a heart shape. **Find a heart-shape leaf and draw or glue it here.**

Lavender
(*Lavandula*)

Marigold or Calendula
(*Calendula officinalis*)

Honeysuckle
(*Lonicera*)

Borage
(*Borago officinalis*)

Poppy
(*Papaver*)

# 176.

In a healthy flower garden—in a healthy world—we need
bees. Here are some herbs and plants you can grow that
bees love. When grown, their scents will fill the air
and butterflies and honeybees will be zooming around.
They will also make you feel happy and calm. **Draw some
bees around these flowers.**

## 177.

A little garden plot is pure happiness, even if it's just one square yard (meter) on a roof or balcony, even if it's just one tomato plant. Growing your own fruit, flowers, or vegetables is stress relieving and uplifting. Plants won't argue with you, but they are alive and breathing. You don't have to pretend you're doing okay around plants; you don't have to dress up. It's just you and your green friends. With a little physical effort, a little perseverance and love, you will receive presents every day in the shape of fruit, flowers, or vegetables. Like Oprah Winfrey said online, alongside a photograph of a big basket filled with her harvest: "I still can't believe how much bounty you get from a few seedlings."

## 178.

If you don't have a yard or outdoor
space yourself, check if there's a
community garden that you can join.
Researchers have found that gardening
is one of the most relaxing ways
to socialize with your neighbors,
and people who work together in a
community garden are less lonely,
healthier, and happier.

## 179.
........

Dissecting a flower to understand how it grows can be a good mindful practice. Perhaps it will even bring back memories —who didn't do this in school? **Dissect a flower and paste or draw the separate parts in the boxes below.**

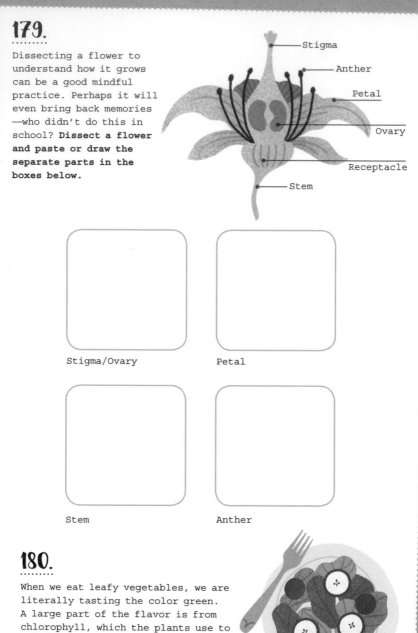

Stigma
Anther
Petal
Ovary
Receptacle
Stem

Stigma/Ovary

Petal

Stem

Anther

## 180.
........

When we eat leafy vegetables, we are literally tasting the color green. A large part of the flavor is from chlorophyll, which the plants use to capture sunlight for photosynthesis and which makes them green. So, if you eat a green leafy vegetable, it's nice to think that you're eating sunlight.

## 181.

If a plant you're caring for is not doing too well, try to find out what it needs, instead of feeling bad about it. Look at it as a project from which you can learn. Did it need more or less water, plant food, or sunlight? **Write about what you've learned so far, and what you haven't worked out yet.**

........................................................................................................

........................................................................................................

........................................................................................................

........................................................................................................

........................................................................................................

........................................................................................................

## 182.

Every fruit and vegetable grows at its own rate. It takes about 100 days to grow a pumpkin and 40 to 80 days to grow tomatoes from seed to fruit. This is just the time they need. You can try to speed up the process by providing light for the plants day and night, but they'll have less flavor. Think of things you try to speed up in your life but which just need more time. **Make notes here.**

........................................................................................................

........................................................................................................

........................................................................................................

........................................................................................................

........................................................................................................

## 183.

In nature, growing can sometimes
mean transforming completely.
The way that caterpillars
turn into butterflies, for
example, is a magical natural
phenomenon. It reminds us that
every successful plan has
phases: a phase of binge eating
(the research you do before you
start); a time to go into your
cocoon and work, work, work;
and a time to break out of the
cocoon and enjoy the flight.
**Write down the stages of a plan
for something you want to do.**

## 184.

Did a caterpillar eat a plant in your yard? Be kind
to it; he'll turn into a butterfly and will help to
pollinate your flowers. **Draw a little caterpillar.**

## 185.

Fruit is a way for plants to get their seeds out into the world. The strawberry is the only fruit with its seeds on the outside of its skin. Eat a strawberry mindfully, using all of your senses. **Note your findings from this tasting here.**

## 186.

One of the most rewarding garden plants is the pea. One single pea of any kind will produce a giant plant that climbs all the way up toward the sky (with a little help from a frame), and the flowers will turn into seedpods containing plenty of new peas. Freshly shelled peas taste so delicious you don't even have to cook them. Look closely at a green pea pod and the peas inside it. **Draw an open pod here.**

Mother-in-law's tongue or Snake plant
(*Sansevieria trifasciata*)

Swiss cheese plant
(*Monstera deliciosa*)

English ivy
(*Hedera helix*)

Barberton or Gerbera daisy
(*Gerbera jamesonii*)

# 187.

Fill your house with plants! A NASA study found that houseplants were able to remove 90 percent of the chemicals that were blown into a test room. The plants found to be best at cleaning the air were the Barberton (gerbera) daisy, English ivy, and the snake plant (mother-in-law's tongue). Monsteras may be less effective, but they grow bigger. **Draw a plant in the empty flowerpot.**

Taking care of plants will also help to take your mind off daily worries and reduce tension. When watering plants, make it a mindful activity. **Hear the water soaking into the soil; picture the plant's roots drinking it up; smell the fresh, green fragrance released.**

**189.**
.........

Some plants have healing powers. The succulent aloe vera, for example, has been used for thousands of years to soothe the skin. When you cut a leaf, you'll see that it contains a gelatin-like substance, and this can be used to soothe and heal light burns. The aloe vera is also a beautiful plant that grows well indoors. **Draw an aloe vera plant.**

**190.**
.........

Making new plants from cuttings is a highly fulfilling activity. Cut off a young stem with a new shoot. Remove two-thirds of the lower leaves and all the offshoot branches. Let the stem form new roots in a glass of water. (This can take up to two weeks.) When new roots have formed, you have a new plant which you can transfer to a new flowerpot.

GROWING

# 191.
..........

The best gardens start with a plan. First, decide what you want to grow and find out when the seeds or seedlings need to be planted. **Draw your dream garden plan on this page.**

# THE LIFE AQUATIC

Most people have happy childhood memories around water: diving into a crystal-clear pool; feeling weightless while floating in water; or scouring for aquatic life at the beach. It seems that water is where we can keep on playing forever; splashing, surfing, boating, swimming, and more.

In the past, it was common to be sent to the coast to recuperate from illness. And still, we go to the beach to clear our mind. Just being near water feels healthy and rejuvenating, and recent research shows this to be true. The UK-based Blue Gym project studied the health and well-being benefits of aquatic environments and found that the sight of water has a positive effect on our mood and reduces stress, in the same way that the sight of a green environment does. But a combination of the two—water with

green surroundings—is even better. The Blue Gym also found evidence that the closer you live to the coast, the healthier you will probably be.

This profound love of water could be a result of evolutionary history. Marine biologist Wallace J. Nichols writes in his book *Blue Mind*: "The reflective surface of water draws humans in the same way it drew our ancient ancestors to drinking pools in Africa—after all, the shiniest thing our ancestors probably saw was sunlit water. Today, it seems that our attraction to the sparkle of watery surfaces is part of our DNA."

Immerse yourself in the life aquatic in this chapter: the animals and plants that live in and around water, the calming sounds of brooks and the sea, waterfalls, and the power of blue.

## 192.

Why do we calm down when we splash water over our faces? It's because the action triggers the mammalian diving reflex. The body thinks that it's going for a swim underwater, so your heart rate drops—making you feel less anxious. **Try it and note the difference before and after.**

## 193.

Blow on the surface of a pool of water and see how your breath makes ripples across it. Try it from a different angle or by blowing more gently. **Draw the pattern.**

## 194.

Flat stones are the best for skimming over water. Hold one with your thumb on top and your middle finger underneath the stone and hook your index finger along the edge. Throw it by flicking your arm horizontally. **How many times can you make the pebble bounce on the water's surface?**

## 195.

The stones in a stream look different from the stones in the sea. Unlike the smooth stones you find on the beach, the stones in a river are often angular and sharp. That's because of the constant collision with other stones caused by the capricious movement of the water. **Collect a couple of small stones from a river and draw them.**

## 196.

Roll up your jeans and dip your toes into the river. Let yourself be refreshed by the cold water; notice how the current passes your ankles. **Feel how the water invigorates not only your feet but your whole body.**

## 197.

The reassuring sounds of waves or meandering streams are said to help us fall asleep and stay asleep. **Listen to a recording of relaxing water sounds and note what it does to your mood.**

## 198.

"Muddy water is best cleared by leaving it alone," said the English philosopher Alan Watts. Often, we're so busy micromanaging our lives that we forget it's sometimes better to give ourselves some space. **Think of situations in your life that might benefit from the "muddy water" approach.**

## 199.

The wonders of buoyancy: Any substance that is less dense than water will float. The density of the human body is a little less than water; if you fill your lungs with air and spread your arms, you might just be able to float. It's a lot easier in salty water, which has a higher density. Floating in the sea can be relaxing as you are cradled by the water and gently rocked by the waves. Close your eyes and think of a moment when you floated on water. **Draw yourself floating in the water.**

## 200.

If you could choose any waterside place to live, where would it be? **Imagine your house by the water and describe or draw it.**

# 201.

If you see a river as a metaphor for
time, and you are standing at a point
that is now, is the future upstream or
downstream? Most people would probably
say downstream because that's where the
water is heading. In Paolo Cognetti's
*The Eight Mountains*, the narrator's
father has a different view—the future
lies upstream because that is what is
coming your way. **Note your reflections
on water as a metaphor for time.**

........................................................

........................................................

........................................................

........................................................

........................................................

........................................................

........................................................

........................................................

# 202.

Dragonflies are water-dwelling insects that can fly at speeds
up to 30 miles (50 km) per hour. Because they're so fast and
can move in any direction they want, they're not shy at all;
they even mate out in the open. In ancient Norse mythology,
they were seen as representatives of Freya, the goddess of
fertility. Some cultures have feared dragonflies, even linking
them to the devil. They're actually harmless—although they do
eat large quantities of flies and mosquitoes. **Draw a mate for
this dragonfly.**

# 203.
.........

Aquatic plants can grow only
in water or in soil that is wet
all the time. Duckweed is one of
the smallest species. The plants
provide shelter, food, and
oxygen, making the water a nice
environment for aquatic life.
Go to a nearby pond to search
for water plants. **Add aquatic
creatures to this page.**

Water lily
(*Nymphaea*)

Marsh marigold
(*Caltha palustris*)

Cape pondweed or
Water hawthorn
(*Aponogeton distachyos*)

# 204.

The water striders or pond skaters that move along the water, the small fish, the colorful dragonflies, little frogs, and floating water lilies: a wild pond or even a pond in a backyard can be a magical place of beauty and serenity. Find a wild or domestic pond and sit next to it for a while. **Note what you see, hear, and smell.**

........................................................................................

........................................................................................

........................................................................................

........................................................................................

........................................................................................

Duckweed
(*Lemna minor*)

## 205.

The Dutch call the reflections of trees in the water *waterbomen*, meaning "water trees." The brighter the sky and the calmer the water, the clearer the reflection. Try to catch a tree reflection with your camera. Experiment: See what happens when you throw something in the water. **Turn the picture upside down afterward and see what happens.**

## 206.

Observe a group of "ordinary" city ducks as if you're seeing them for the first time in your life. **Make notes about their behavior.**

## 207.

The swan is a symbol of love. Swans have the same mate for their whole life, and when they court their necks form the shape of a heart. **Draw a second swan opposite this female, creating the shape of a heart together.**

Some trees love having wet feet. Unlike a
lot of other trees, they have developed the
ability to grow roots without needing air.
The beautiful willow, for example, can grow
in almost any wet area in virtually any
climate. The weeping willow always feels
like a very poetic tree and has inspired many
artists with its elegant arching stems. **Draw
a weeping willow "crying" by the water.**

## 209.

Most of us have happy childhood memories of playing with water, whether it was building a dam, swimming and diving, or playing on riverbanks and trying to catch little frogs and toads. **Make a bullet list of your happy water memories. Which ones would you like to experience again?**

- 
- 
- 
- 
- 
- 
- 
- 
- 

## 210.

The waterfall ritual is a practice in Shinto, the indigenous religion of Japan. Shinto means "Way of the Gods," and the gods, *kami*, can be found in all nature elements: in the moon, the wind, an unusually shaped rock, or a waterfall. Whether you practice Shinto or not, standing under the cold, cold water of a waterfall is an intense experience. When in the shower, adjust the water so it is cold, close your eyes, and imagine you are under a waterfall. Afterward, notice your blood pumping, leaving you feeling energized and awake.

# 211.

"The whole world is a series of miracles . . . but we're so used to them we call them ordinary things," said Hans Christian Andersen, the Danish writer of fairy tales. Water, indeed, is a miracle. Think about the variety of shapes and forms water comes in—from ice to dew, from the spray of the ocean to misty clouds in the mountains—it's incredible. **Fill these squares with symbolic drawings of all the forms of water you can think of.**

## 212.

*Thalassophile* is the Greek word for "lover of
the sea." Many people who live near the ocean
are thalassophiles at heart. I know I am. Most
people go to the beach only when it's sunny, but
I prefer the beach when the weather is dreary. The
wind and the wild sea clear my mind and make room
for new thoughts. I love the empty beach and the
gray water with nothing to see but the long white
stripes of the waves, and maybe some boats in the
distance. When it's a sunny day, my favorite
hours are at the end of the day, when everything
looks as though it's been sprayed with a layer
of gold. **What is your ideal beach hour?**

# 213.

Waves are the result of the constant
interaction between wind pushing and
gravity pulling the water. Listen
to the ocean within you, your breath
like the waves lapping ashore,
continually coming and going. **Let
your breathing take its natural
course; don't try to change it.
Just accept it how it is.**

# 214.

The tree most associated with the
sandy beach is probably the palm tree.
Did you know that many palms aren't
actually trees but flowering plants,
just with less striking flowers?
The trunk is, in fact, the stem and
doesn't have annual rings like a tree;
that's why it doesn't increase in
width. **Draw a palm tree on this beach.**

## 215.

All shells were once some animal's home. Find a seashell and touch the ribbing on the outside, the smooth surface on the inside. Hold it up to the sun so you can see all the colors. **Draw the shell.**

## 216.

Make a mandala (loosely meaning "circle" in Sanskrit) on the beach. Create a circular design with repetitive shapes and colors radiating from the center. Use stones, seashells, and other things you find when combing the beach. **Try not to overthink it; just enjoy the process of creating.**

## 217.

To make a necklace or garland with shells, you can drill a small hole in each using a hand drill from a craft or hobby store. But there may be no need: on the beach you can often find shells that already have holes in. **Find some shells with holes and use them to make a necklace.**

## 218.
........

The feeling of looking at the water, with no rush to get somewhere, speaks to many people—maybe because we do it too little. **Schedule some time to be out by the ocean and just stare and let your mind wander.**

## 219.
........

When it's sunny and there are small waves on the surface of the water, it sometimes looks as if a thousand suns are being reflected. **Make a sketch of sun reflecting on the water.**

## 220.
........

Flamingos are perhaps the most iconic waterbirds. Why do they stand on one leg? Scientists have only recently discovered that it's actually more comfortable for them to stand on one leg instead of two. It costs them less energy. For humans, it's entirely the opposite; to stand on one foot, we need our full attention. That's why one-legged standing poses in yoga make us forget daily worries—we need to concentrate on keeping our balance. **Try to stand on one leg, clearing your head and becoming one with your body.**

THE LIFE AQUATIC

## 221.
. . . . . . . . .

The beach or any sandy area is a
perfect place for a mindful walk.
Walk in bare feet and focus on the
movement. "Walk as if you are kissing
the earth with your feet," says the
Vietnamese spiritual leader Thich
Nhat Hanh.

## 222.
. . . . . . . . .

The color of an ocean or a lake changes all the time.
**Use paints to mix up a color palette for water.**

## 223.

Draw a wild ocean with big waves.
Add one small boat on the water.
The waves are your thoughts. The
boat is you. When meditating, you
become a submarine. The wild waves
are above your head; they are
there, but they don't affect you.

# LOOK UP TO THE SKY

Many of us are well aware of the weather, but mostly through the apps on our phones or by looking out of the window. In bad weather, we'd rather stay in, and when it's hot outside, air-conditioning cools down our offices. No matter what the weather is like outside, inside we control our environment to provide the comfort of one regular temperature and humidity.

The thing with humans is that we systematically underestimate how good nature makes us feel, while at the same time we overestimate how good we feel when indoors. Scientists call these flaws in our predictions "forecasting errors." The problem is that we base our actions on these flawed forecasting skills. We choose comfort, only for it to make us feel bored in the end.

I love the Swedish expression "there is no bad weather, only bad clothing." To appreciate the sky's true beauty, we must go outside. A gray day can be beautiful when you're out in nature enjoying poetic misty landscapes or experiencing that magical moment when golden sunrays break through the clouds, casting a beautiful glow.

To fight our misleading judgments, this year my motto has been "if it doesn't work inside, go outside." Whenever my kids are arguing, whenever I'm down and ruminating over the state of the world, we go out. No excuses, out we go. We smell the soil after rain, feel the wind on our skin, look at the clouds. We always feel better afterward. As Dolly Parton said: "If you want the rainbow, you gotta put up with the rain."

## 224.

Before you start your day, take a quiet moment to go outside in your bare feet and get in touch with the temperature outside. Feel the ground under your soles. Take a couple of deep breaths, inhaling the morning air. **Make some notes about what you see, hear, and feel.**

......................................................................................................................................

......................................................................................................................................

......................................................................................................................................

## 225.

If you want to know what the weather is going to do, look at the animals. There are many proverbs about animal behavior predicting the weather. Some count as superstition, but others do make sense. Restless animals are normally a sign of bad weather. For example, robins perching in bushes in the middle of the day, or swallows flying low. Birds can detect subtle changes in air pressure and start foraging food quickly, because well-fed birds have the best chances of survival. **See if you can notice a connection between animal behavior and a change in the weather.**

## 226.

Frogs need fresh water to lay their eggs. When rain is on its way, their mating calls become louder to increase their chances of finding a mate. So, once the rain has increased the number of vernal pools and temporary ponds, they are ready to breed. **Draw some frog eggs here.**

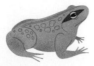

## 227.

How much rain falls on a rainy day? To gain more of an understanding of the volume that comes down from the sky, install a rain gauge or make one yourself. Use a glass jar or cut a plastic bottle in half. Fill it with a layer of pebbles so that it doesn't tip over, and fill it with water to just above the pebbles. From that point use a ruler to add measurements with a black marker.

## 228.

Gray day? Go outside! While from the inside it may look like the day is only gray and gloomy, once you're out in nature you'll notice that a gray day can have many beautiful moments: misty mystical landscapes, sunrays breaking through the clouds, a sudden rainbow. **Make notes about what you can see in and beyond the grayness.**

........................................................................................

........................................................................................

........................................................................................

........................................................................................

........................................................................................

........................................................................................

........................................................................................

........................................................................................

## 229.

The pinecone is a natural weather forecaster. When the air is humid and it's going to rain, the cone will close; when the air is dry, it will open up. By placing a pine cone on a string outside your house, you can have your own primitive weather station.

## 230.

Making a weather report of your current mood and emotions is a well-known mindfulness practice. What's the weather like inside your head? Is it cloudy? Is it sunny? Do you feel a thunderstorm coming? **Note or draw your own little symbols for how you're feeling right now.**

## 231.

Instead of closing your window when it rains, open it. Listen to the pitter-patter of raindrops falling. Just listen. **Make notes about the experience.**

## 232.

We have become so used to central
heating and wearing warm clothes,
that being cold feels unnatural.
But being cold is, however, a
natural state for the body to be
in; after all, we evolved without
central heating or shoes. Some
researchers are stating that
we should expose our bodies to
cool temperatures more often to
stimulate blood flow, remove toxins
from the blood, and strengthen
our immune systems. Next time
you're cold, before you turn up the
heating, try to relax your muscles
and breathe in deeply (if you don't
have asthma). Be mindful of how
your body reacts. Remember that
it's just your skin that is cold;
your inner body temperature
is still around 98.6°F (37°C).
**Write about your relationship
with the cold.**

## 233.

Cold-blooded animals, such as
lizards, need heat from the
outside, because they can't
generate their own. That's
why you'll often find them
sunbathing, absorbing heat
from the sunlight. We're not
cold blooded, of course, but
we've all had moments when
we felt our batteries being
recharged by the sunlight,
perhaps when we were really
tired or cold. **Describe a
moment when you have felt
reenergized by the sun.**

## 234.

Wind has always symbolized change—the change you cannot yet see, but can already feel. Whether it's a breeze or a hurricane, it's caused by the same principle: air moving from high to low pressure areas. Birds use air currents for flying; plants and trees use moving air to spread their seeds. Although we might not notice it so much, wind affects us, too. If you have children or work with children, you will know how restless they get when the weather is windy. **Make a quick nature connection just by working out which direction the wind is blowing in; look at a flag or point a wet finger at the sky. Notice the sensations of the wind on your skin.**

## 235.

We may not be able to see wind itself, but we can see its effects. Observe a tree on a windy day. How do the branches sway back and forth? How do the leaves move? Meditate by looking at the tree and slowly breathing in and out. When your mind starts to drift off to your to-do list, bring your attention back to the tree.

LOOK UP TO THE SKY

## 236.

The interaction of dried leaves on the ground, dancing in the wind, spinning in circles, is beautiful to watch. **Add more swirling dots and dancing leaves to this wind pattern.**

## 237.

Make a simple windcatcher out of a thin fallen branch, string, and objects you have found in nature, such as feathers, shells, leaves, or anything else that will easily catch the wind. **Tie the objects to the branch (or use an embroidery hoop), and hang it somewhere that the wind blows.**

## 238.

Sailors and windsurfers know the powerful feeling of catching the wind and moving in their chosen direction. "It is the set of the sails, not the direction of the wind, that determines which way we will go," is a famous quote by the motivational speaker Jim Rohn. You don't have to follow the current, he said; a little head wind can make you go faster. **Draw a small sailboat and think about the metaphorical winds in your life.**

## 239.

The animals that really know how to work the wind are the birds of prey, such as condors and buzzards. With their majestic wings, they let themselves be carried by thermals—upward currents of warm air—all the while looking for prey in the high grass below. If you see a bird of prey, lock your eyes on it for a while. **Draw the swirling flight pattern of the bird.**

## 240.

When things get really chaotic around you, the tornado meditation might help. A tornado is caused by differences in air pressure, which make the air move. At the outer edges of a tornado, the pressure is high, with the air in motion sweeping everything off its feet. But no matter how destructive a tornado is, in the center there is complete silence. **Find the silence inside yourself when everything around you is in motion.**

# 241.

The brighter the sun, the clearer the shadows. **Draw the shadows cast by different objects.**

# 242.

Sungazers believe that looking at the whole sun improves mental and physical health, rest, clarity, and memory. Just after sunrise or just before sunset, when the UV index is low (however, still wear sunglasses), look for a couple of seconds at the sun. **Stand in bare feet on grass, sand, or any other natural surface. Relax your muscles, especially those in your face, and inhale the energy.**

# 243.

On a hot day, the shade of a big tree can offer a lot of comfort. And with the green smell and soft sound of the rustling leaves, it beats any other type of shade. Research shows that trees reduce UVB exposure by about 50 percent. Fast-growing trees that can provide shade for your yard include the poplar, weeping willow, and maple. **What is your favorite shade-giving tree?**

.......................................................................................

.......................................................................................

# 244.

Surya Namaskar are the yoga moves to greet the sun, also known as the sun salutation, and nothing beats the feeling of practicing it outside. In the Vedic tradition, the sun is symbolic of consciousness. Don't force anything; just accept the state of your body as it is in this moment.

# 245.

To work out how much time is left before the sun disappears behind the horizon (or a mountain), you need only your hands. Hold up one arm with your wrist bent so your hand is sideways and your palm is facing toward you. Line up your hand with the horizon. Every finger between the horizon and the sun represents about 15 minutes. The measurement is most accurate within two hours of sundown.

**246.**

Knowing something about clouds will make it more interesting to look at them. The high-in-the-air feathery clouds named cirrus and cirrostratus are formed of tiny ice crystals and tell you bad weather is probably on its way. When the clouds are fluffy and look like big cotton balls (such as cumulus and altocumulus), you can expect sunny weather. When a cumulonimbus is forming, with a large anvil-shape top, get inside—there is serious thunder ahead.

Cirrostratus

Cirrocumulus

Altocumulus

Altostratus

Stratus

## 247.

Perform a cloud meditation by
lying on your back and watching the
clouds drifting by. Realize that
everything is moving: the clouds
you are looking at, the earth
you are resting on. Feel gravity
pulling you down.

Cirrus

Cumulonimbus

ratocumulus

Cumulus

## 248.

A blue sky is nice enough, but a cloudy sky can be fascinating. At least, that's how the members of the Cloud Appreciation Society look at it. The society's members share online the most beautiful pictures of spectacularly shaped clouds and enchanting colors. **Take photographs of interesting clouds you see this week, or make little sketches here.**

## 249.

Snow crystals are absolutely stunning when you look at them closely enough to make out their symmetrical shapes. A close-up of an ice crystal looks like an expensive piece of jewelry. You can have a good look when the crystals form on windows or sometimes even on spider webs in the winter. **Draw ice crystals on this window.**

## 250.

The immense power of nature is easily visible when thunder rumbles and lightning strikes. No wonder our ancestors saw these phenomena as signs from their gods. If the electric charge in a cloud gets high enough, it generates a giant spark that leaves the cloud. Thunder is the sound made by the lightning causing air to heat and expand rapidly. **Draw lightning strikes from this cloud.**

## 251.

Surrender to the rain. Let the raindrops touch your face. Stay warm by being active. Watch the puddles gather rainwater. Put on your rain boots and jump around in them. It might feel a little uncomfortable at first, but it's refreshing in the end. You'll feel alive.

## 252.

Ginger is one of the best spices to give you a boost on a cold day. **Place ¾ inch (2 cm) sliced and peeled ginger root in a mug of boiling water. Add honey and some fresh lemon juice. Let it brew for 5 to 10 minutes and then enjoy the warming infusion.**

LOOK UP TO THE SKY

# DOWN TO EARTH

The first time I discovered black, fertile soil underneath a pile of garden waste, I was ecstatic. You see, there had never been black soil there before; this was new black soil, the result of composting.

To be fair, I did find it at the bottom of the garden composter we had put into our yard, which was intended to produce soil. But until I saw the result, it was all abstract to me. I had just thrown in my failed attempts to grow broccoli, dead leaves, and some moldy potatoes; I didn't expect this waste to actually change into something I could use again. Microbes and tiny soil-dwelling animals had turned this pile of mess into healthy, fertile soil. It was the circle of life in action. No wonder gardeners call this soil "black gold."

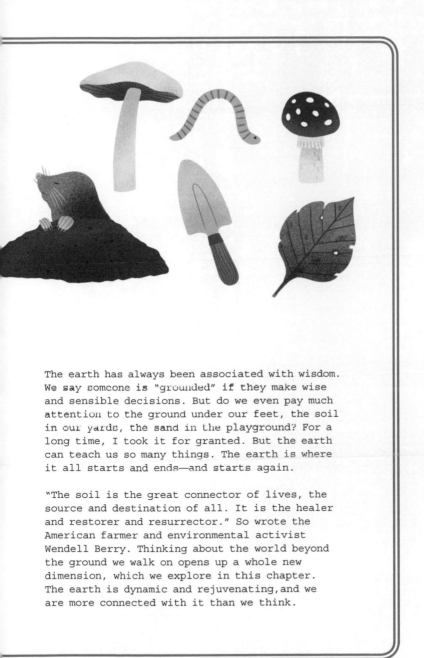

The earth has always been associated with wisdom.
We say someone is "grounded" if they make wise
and sensible decisions. But do we even pay much
attention to the ground under our feet, the soil
in our yards, the sand in the playground? For a
long time, I took it for granted. But the earth
can teach us so many things. The earth is where
it all starts and ends—and starts again.

"The soil is the great connector of lives, the
source and destination of all. It is the healer
and restorer and resurrector." So wrote the
American farmer and environmental activist
Wendell Berry. Thinking about the world beyond
the ground we walk on opens up a whole new
dimension, which we explore in this chapter.
The earth is dynamic and rejuvenating, and we
are more connected with it than we think.

DOWN TO EARTH

## 253.

When walking outside, stop for a moment and look down at your feet. What are you walking on? **Take a snapshot at a random moment today. Draw the ground underneath your feet.**

## 254.

Sit up straight and take a couple of deep breaths. Park your thoughts and to-do lists for a second. Close your eyes and concentrate on the crown of your head, then your neck, and then the vertebrae down your back. Visualize your body as an extension of the earth. **Imagine that you cling to the earth, and that you let all your stress and worries flow into it.**

# 255.

Researchers have discovered that *Mycobacterium vaccae*—a bacterium that is commonly found in soil—reduces anxiety and increases the serotonin level in our brains. You can inhale the bacteria when you work in your yard. As a result, you start to feel more positive and relaxed and think more clearly. **Dig into the ground! Recall a moment when you found peace in gardening.**

# 256.

Be careful not to step on the small creatures that walk the earth, such as the scarab beetles, with their beautiful hardened shields in metallic colors. The shiny black dung beetle was sacred in ancient Egypt. The hieroglyph representing the beetle, Kheper, refers to growth and development. **Color in these beetles.**

# 257.

In the city, you walk on either stone or concrete. There may be a little grass in the mix sometimes, but still, the variations are pretty limited. But in nature, the ground under your feet can have endless variations: stones, sand of all colors, moss, clay, mud, leaves, a bed of pine needles. **Think of the different types of ground you've had under your feet and draw a collection in these jars.**

# 258.

Healthy soil is swarming with bacteria, fungi, and other organisms. A single handful of soil can contain thousands and thousands of different species. **Draw colorful microbes and other organisms.**

## 259.

Who doesn't love the smell of soil after a rain shower? Decades ago, Indian perfumers were able to capture the scent in a perfume bottle. They called it *mitti attar*. Researchers have found out only recently what causes the aroma. When a raindrop hits the soil, it traps a tiny amount of air. These bubbles then speed upward and erupt into a fizz, releasing the bacteria that cause that specific smell, a scent that humans are extremely sensitive to. **Make notes about what you see, hear, and smell when you pour water over the soil.**

....................................................

....................................................

....................................................

....................................................

........................................................................................................

........................................................................................................

........................................................................................................

........................................................................................................

........................................................................................................

## 260.

The element earth is associated with the geometrical shape of the cube. The cube stands for grounding, stability, and calmness. Some people believe holding a cube-shaped object, such as a die, generates grounding energy. You could also visualize a cube around you while meditating. **Decorate this cube.**

## 261.

Roots, fungi, all the animals that live underground, both big and small—there is a lot going on underneath our feet. We see only the surface, but the earth consists of different layers of soil. You will see these layers when you start digging a deep hole. First, there is an organic layer containing all the plant remains, then the topsoil composed of broken-down organic matter and minerals. What you find when you dig even deeper depends on where you are. How was your land shaped? What was there thousands of years ago? No matter where you are, deep down below your feet, underneath the slowly moving tectonic plates that shape our continents, there is burning-hot magma. Visualize the world below your feet.

## 262.
.........

What can you hear when you put your ear to the ground? **Note down any sounds you hear and what you think they might be.**

## 263.
·········

A wilted flower or a decaying leaf will
soon be part of the earth again, and
fruit and flowers will release their
pollinated seeds. It's the circle of
life. **Glue and/or draw a wilted flower
or a half-decayed leaf here.**

## 264.
·········

Find out what the soil type is in your backyard. Fill a pitcher
halfway with soil and add water to almost fill it. Stir it up
vigorously, then let it stand undisturbed for 24 hours. It will
split and settle into layers of sand, silt, and clay.

Water
Clay
Silt
Sand

## 265.

Making your own compost is easier than you think. You'll need green items, such as vegetable waste, old herbs, plants, and fruit. You'll also need dry, brown items, such as dried leaves. Layer them up. Coffee grounds are also great. Add more dry leaves if the compost is too wet; add more greenery or water if it's too dry. Add some red wigglers or tiger worms and an organic compost starter. Microbes will do the work. After some months, you'll have compost that feels like crumbled chocolate cake.

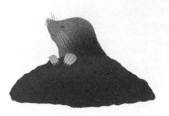

## 266.

Moles are often seen as a nuisance in the yard, but they're actually a good sign. Molehills mean that your soil is healthy and there are plenty of worms. Moles will eat slugs and the larvae of insects that harm your plants, and they'll increase the quality of the soil by mixing the different earth layers and adding air. Look at the molehills and try to picture the network of tunnels. **Draw them here.**

## 267.

Stamp your feet on the ground to make worms think that it's raining and encourage them to appear from the soil. Then you can transfer them to your compost pile.

# 268.

Mushrooms and toadstools are the "fruit" of fungi; what you see is just a small part of their true bodies, which are mostly under the surface. Some are delicious; some are deadly. When they spring up from the ground, they can double their size in 24 hours and change shape completely. **Find a mushroom or toadstool. Can you find another of the same species that is younger or older? Note the differences.**

Fly agaric
(*Amanita muscaria*)

False death cap
or Citron amanita
(*Amanita citrina*)

Big sheath mushroom
(*Volvopluteus gloiocephalus*)

Bronze bolete
(*Boletus aereus*)

Chanterelle
(*Cantharellus cibarius*)

Lepiota
(*Lepiota clypeolaria*)

Parasol mushroom
(*Macrolepiota procera*)

Penny bun bolete
(*Boletus edulis*)

Black truffle
(*Tuber melanosporum*)

## 269.

Finding mushrooms in the forest has been compared to trying to find a solution to a complicated problem. You will not find them by focusing on one point. But if you keep an open view and relax your focus, you will see what was already there waiting to be discovered. **Describe an "a-ha" moment you had when you were in a relaxed state of mind.**

...................................................................

...................................................................

...................................................................

...................................................................

...................................................................

...................................................................

...................................................................

## 270.

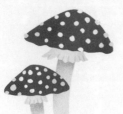

Mushrooms and toadstools have always sparked people's fantasies. There's something about the way they spring up from the ground overnight and their odd shapes and bright colors. Did you know there are toadstools shaped as umbrellas? You can even find mushrooms that resemble bright red gramophones or big hairy yellow balls. Mushrooms often grow in an arch or full circle, which is called a fairy ring or, in some countries, a witch circle. **Draw a fantasy fairy ring.**

## 271.

Messy yards can be healthy yards! When working outside, don't throw away cuttings and dead leaves, but make a little pile at the back of your yard. It will serve microbes, fungi, and ground bugs. It will attract birds. And the result will be a flourishing yard that is full of life. **Draw some extra garden waste on this messy pile.**

## 272.

...................................

...................................

...................................

...................................

Rocks provide shelter for many little insects, who like the darkness and humidity of the ground underneath. Carefully turn over a rock and look at the busy world of ground bugs hiding from the sun. **Make a list of the different insects you find.**

...................................

...................................

## 273.

Sometimes, when you sit down in nature and take a moment to relax, you will suddenly see that there is a lot more activity around you than you noticed at first: especially when it come to ants! They work frantically to carry food to their nest or bring unwanted debris and dead ants to a waste pile (they like a clean house). They can carry things 10 to 50 times their own weight. **Look for an ant carrying the largest luggage and draw it.**

## 274.

A study shows that ants know how to find their way back to their home by counting their steps. They have an internal pedometer! Look for an ant and follow its route. Investigate where it's going. **Make notes on its path.**

...................................

...................................

...................................

## 275.

When cut and polished, crystals, minerals, and some rocks are called gemstones. For millennia, they have been associated with healing powers or special energies and used to improve well-being. Whether or not they really do have healing powers, they are little wonders of nature, collected by many people and used in jewelry. **What gemstones do you own and how did you get them?**

Rose quartz

Red jasper

Citrine

Amethyst

Amazonite

Tiger's eye

Fluorite

Amber

Sunstone

## 276.

Find a smooth stone to paint on. Using a white marker, you can make beautiful designs on black or gray stones. **Write the date and finding place on the back. (You can start by decorating the stones on this page.)**

## 277.

Give yourself a natural foot massage. Walk with bare feet on small stones to massage your soles.

## 278.

We should opt for the "stone strategy" more often, says German philosopher Holm Friebe. Instead of always acting, it's sometimes better to choose calm and serenity. To be like a stone and wait for the storm to blow over. To be silent instead of always filling the air with words. **When would the stone strategy work for you?**

.......................................................

.......................................................

.......................................................

.......................................................

.......................................................

.......................................................

## 279.

Sand is made up of rocks that have eroded over thousands of years. High in the mountains, part of a stone breaks off and finds its way into a river. During its long journey in the river it breaks into smaller pieces, eventually ending up in the ocean, where the constant waves make them even smaller and rounder. River sand is normally more coarse (and better to build castles with!) than the sand on a beach. The color of the sand depends on the ground source. Beach sand, for example, can also contain tiny parts of animal life, such as coral and shells. Every beach has its own type of sand. **Draw some grains of sand with the help of a magnifying glass.**

##  280.

When you try to hold fine sand really tightly, it slips through your fingers. When you relax your hand, you're able to hold it. Some say it's the best metaphor for a healthy relationship. **Let some sand slide through your fingers. Note how the sand feels against your skin and what your feelings are on releasing it.**

...................................................................................................

...................................................................................................

...................................................................................................

...................................................................................................

...................................................................................................

...................................................................................................

...................................................................................................

## 281.

Sand is a natural cleaning product. That's why a lot of animals like to take sand baths. You can make a natural hand scrub by mixing equal parts of coconut or olive oil with beach sand (which you can buy at a hobby store).

# 282.

.........

Create a picture with different kinds of sand. Put some glue on the page in the shapes you want.

# INTO THE FIELDS

Meadows, grasslands, and hills—artists have been grateful for these landscapes all through the ages. Who doesn't love Monet's fields of poppies or van Gogh's rural landscapes? The vastness of it all, the view of the horizon, the swaying grass, a bird here and there, a certain tree, no wonder they are so inspiring.

It turns out that our love for open fields and what they offer is pretty universal. In the TED talk "Darwinian theory of beauty," Denis Dutton speaks about a survey where people were asked to describe a "beautiful landscape." No matter where people were from, no matter what culture, the answers were surprisingly similar; an open space covered with low grass, diverse greenery, some trees, and water in the distance. Dutton

explains this using evolution. The open field
means we can see approaching danger, occasional
trees we can climb if necessary. The landscape
described resembles a typical savanna—and the
savanna is where humans evolved 200,000 years
ago. We love it because it helped us survive.

It's not just humans who love it; meadows and
grasslands are a crucial habitat for hundreds of
species of flowers, grasses, birds, and insects.
And for them, these landscapes are still
necessary to survive. So let us be more aware
of them, as moviemaker Jonas Mekas encouraged:
"In a meadow full of flowers, you cannot walk
through and breathe those smells and see all
those colors and remain angry. We have to
support the beauty, the poetry, of life."

## 283.

Van Gogh wrote in a letter to his brother Theo that he loved to draw landscapes. He tried to discover the human emotions in scenes, as though everything had a soul. "A row of pollard willows has something of a procession of orphans," he said. "The young corn may have something unspeakably pure and soft, which triggers such an emotion as the expression of a sleeping child." **Look at a landscape through van Gogh's eyes. What comparisons come to mind?**

## 284.

Every part of the day has its own quality of light. In the morning, as the sun rises, the world gets brighter every minute. In the evening, when the sun sets, the light takes on a softer tone. **Take photographs at different times during the day and become aware of the changing nature of light.**

## 285.
..........

Imagine you were a bird and could fly through the sky. **Draw the landscape around you as you would see it from a bird's-eye view.**

INTO THE FIELDS

## 286.

A wild meadow is alive with energy: the flowers, the birds, the buzzing bees, butterflies, and other insects. If you find a field with wild flowers growing, cherish it. When you can, lie down among the flowers to feel really connected with nature. **Draw a meadow on this page.**

## 287.

Scientists have found that flowers give off minute electrical signals, as an additional way to attract pollinators. **Imagine you could sense and even see the signals flowers are sending and add them to your drawing.**

## 288.
......

When you take the time to sit and look, nature reveals its hidden beauty. Sit in the long grass and look for the spider webs that are stretched between the blades of grass, sometimes with drops of dew upon them, sparkling like diamonds in the sun. **Draw what you see from a low perspective.**

## 289.
......

When you lie in a meadow on a warm day, you can sometimes see the air vibrate just above the grass. The ascent of the hot air causes movement in the air layers, causing the light to break in different ways. **What else do you notice above you?**

## 290.
......

Birds love meadows; some of them even breed in the open field. It can make a big difference to bird populations when farmers start mowing a little later in the year, after their nesting season. Take your binoculars into the fields and look for birds. **Make notes of what birds you see and hear.**

## 291.
........

The scent of freshly cut grass is actually the smell of grass's defense system. When harmed, grass releases chemicals to try to protect it from being eaten. However, cows and other ruminants don't mind. **Pick some grass and smell it. Make notes.**

......................................................................

......................................................................

......................................................................

......................................................................

......................................................................

......................................................................

## 292.
........

Have you ever found a four-leaf clover in a grass field? They're hard to find, but not impossible. The Swiss organization Share the Luck discovered by counting five million clovers that the ratio is 1 to 5,000. There are also five-leaf clovers, although they're even rarer. Spend a mindful couple of minutes looking at clover plants. **Glue or draw some here.**

## 293.
..........

If you can't find a lucky four-
leaf clover, make your own luck.
**Cut clover leaves from colored
paper and glue them on this page.
Arrange them in a pattern.**

## 294.
.........

Researchers from the
University of Cambridge in
England have found that sheep
can recognize human faces. But
can we recognize individual
sheep? Go to a visitor or
children's farm where they
have sheep and observe their
differences. **Draw a sheep's
head and give your creation
a name.**

## 295.

We have slowly lost connection with where our food comes from. What crops grow in your neighborhood? Go on an agricultural expedition in your area to find what kinds of plants grow nearby. **Do any of them make it to your plate?**

## 296.

When you drive through the countryside, you might find farmers or amateur growers selling some of their harvest or produce, such as strawberries or honey. Buying these foods is a nice way to be in touch with what grows locally, to taste the land. **Fill this table with locally grown products.**

## 297.

Swaying fields of wheat or corn occupy more land area than any other food. Our ancestors started cultivating these crops thousands and thousands of years ago, and throughout the world, they are eaten every day. **Investigate and draw a fresh ear of corn.**

## 298.

Crows love agricultural landscapes. They are highly intelligent birds, so scarecrows have never been effective. Some farmers still use them just for fun. **Draw a scarecrow.**

## 299.

Every individual crow has a different call, and they're able to recognize each other by voice. If you listen carefully, you can hear the differences in cawing. **Listen to crows "talk" to each other.**

# 300.

Hills are sometimes former mountains that have been worn down by erosion over many thousands of years; sometimes they are human-made. Some rolling landscapes were sculpted by glaciers long ago. Hills may be less impressive than mountains, but they can be beautiful nonetheless. And they're easy to climb. The fact that we humans like views so much has to do with evolutionary psychology. Being able to see possible danger from a distance makes us feel safe. A broad view also helps our creative thinking. **Climb a hill today.**

## 301.

Looking into the distance is relaxing not only
for your soul but also for your eyes. We look at
our computer and phone screens so much that we can
develop problems with our eyes. Get up at least
every two hours when sitting at a screen and rest
your eyes for a couple of minutes by looking into
the distance. Notice the difference in your eye and
facial muscles when focusing on something far away.

INTO THE FIELDS

## 302.
..........

"There are no lines in nature, only areas of color, one against another," said the French Impressionist painter Édouard Manet. **Draw a hilly landscape without lines using only dabs of colors.**

## 303.
..........

Pick one detail from your view and give it your full attention. Perhaps even grab a pair of binoculars to get a good look at it. **Draw this feature in the hilly landscape you created above.**

## 304.

Grasshoppers always seem to have so much fun together, hopping onto each other's backs and jumping around. They use their legs as a catapult, which means they can jump 20 times their own length. They've been around for a while, too: grasshopper fossils have been found dating back about 250 million years. **Find a grasshopper and observe it. Calculate how far you could jump if you had legs like a grasshopper.**

## 305.

The petals of a flower turn toward the sun to catch its rays. In a field of sunflowers, it's hard to miss the fact that the flower heads turn to face the sun. **Stop and reflect on your own movement toward things that energize and strengthen you. Do you turn toward them as much as you'd like to?**

## 306.

A horse can sense when you're tense or relaxed. Recall an interaction you have had with a horse. **Did you get a sense that the horse understood how you were feeling?**

## 307.

You can see large, round straw bales sitting in fields after the harvest. Do you know the difference between hay and straw? Hay has a greenish color, because it's composed of dried grasses and plants, such as clover. It's used to feed horses and other animals. Straw is what's left when the grains and chaff have been removed from cereal plants. It has a golden yellow color and almost no nutritional value. **Draw bales of straw of different shapes.**

## 308.

Practice meditative walking in an open field. Walk more quickly than you usually would and set your gaze just above the horizon. After a while you will forget it is you that is walking: the "self" disappears, and you reach a state of flow.

## 309.

Describe the changes in the colors and structures of an agricultural landscape in your area. **What happens in each season?**

Spring:

Summer:

Fall:

Winter:

## 310.

When watching the sky at sunset during fall
or winter, you may be lucky to witness the
mesmerizing phenomenon of a murmuration:
hundreds or even thousands of birds flocking
together and performing what looks like an
aerial ballet. Starlings, cowbirds, and
blackbirds are known to exhibit this mysterious
flocking behavior moments before the sun
sets and they go to sleep. Researchers think
they gather in these large groups to confuse
predators, such as hawks and owls. **Draw bird
silhouettes against an orange sky.**

# TRAVELING
# AND TRAMPING

Whether you call it hiking, wandering, tramping, or roaming, discovering the great outdoors on a long walk "fills our hearts with speechless, quiet reverence and resignation." This was composer Robert Schumann's view, one supported by his fellow Romantics, Goethe and Schubert, who would also set forth in the forests of Germany to explore nature, and each produced beautiful works with a nature theme as a result.

Just walking in nature is probably one of the best ways to connect with nature. You develop a rhythm in your walk through the continuous physical movement; you switch off your mind and

enter a different state. For ancient pilgrims,
walking was not only a way to get to their
destination but also an opportunity to meditate,
reflect on life, and hear their inner thoughts.

But hiking in nature also involves testing
ourselves as we explore new places and
challenge personal boundaries. You have to
have some determination to go hiking, and if
you're going on a long trail, you need to do
some serious preparations as well. But once
they're done, nature's there for us, calming
our over-stimulated minds step by step. See the
landscapes change, discover new places, enjoy
the gentle sounds of rustling leaves and singing
birds. Drink some water when you're thirsty, sit
down to rest when you're tired. It's simple and
lovely. Here's to wanderlust.

# 311.

Can't stop the constant repetition of negative thoughts? Go for a brisk walk in nature. Research carried out at Stanford University in California showed that a 90-minute walk in a green environment deactivates the part in your brain that is associated with negative thinking. **Note your thoughts before and after the walk.**

Before:

.........................................................................................................

.........................................................................................................

After:

.........................................................................................................

.........................................................................................................

# 312.

We are advised to walk at least 10,000 steps a day. Most smartphones have a standard pedometer, which can measure your daily step count. Note how many steps you take every day this week. **Think of ways that you can increase your step count.**

Monday: .........................................................................................

Tuesday: .........................................................................................

Wednesday: .....................................................................................

Thursday: ........................................................................................

Friday: ...........................................................................................

Saturday: ........................................................................................

Sunday: ..........................................................................................

## 313.

Walking together is a powerful
way to connect with someone. The
calming effect of nature, the fact
that you're not looking directly
at each other but have each other's
attention, and the fact that there
is less chance of being disrupted,
makes people talk more freely. Even
if a big part of the walk is in
silence, people experience a deep
sense of togetherness during a walk.
**Invite someone to come on a walk
with you.**

## 314.

If you walk forward, as you normally
would, you tend to focus on the place
you're walking to: your goal. Dutch
artist Johannes Bellinkx organizes
outings where you walk backward.
By walking backward, your goal
disappears. Your focus widens and
the landscape unfolds itself for you
with every step. Try it with a friend
and write about your experience.

##  315.

Look up! The canopy of trees above your head is breathtaking. A surprising way to walk through a forest is to have a little mirror in your hand and experience your walk upside down. Go with a group of people and make a little train by placing your hand on the shoulder of the person in front of you. **Draw your view of the branches above you here.**

## 316.

"All truly great thoughts are conceived while walking," said the philosopher Friedrich Nietzsche. He was right. Modern brain research shows that walking has a positive effect on cognitive processes and can literally lead to more "wisdom." **Go for a walk and write down your thoughts afterward.**

## 317.

Taking a rest outside in nature is
one of the best things there is. When
you're on a hike, take a break when
you feel tired and lie down in a sunny
spot. Listen to the sounds, the wind,
the peaceful nothing. If possible,
take a short nap. Slowly start moving
your fingers and feet before you get up
again. Start by noticing the sounds,
smelling the ground. Mindfully, get
up and continue your hike.

## 318.

Bring a small nature souvenir home
from your hike, perhaps something you
found on the ground. **Glue or draw the
object here and write down when and
where you found it.**

When found . . .

.....................................................................

.....................................................................

.....................................................................

Where found . . .

.....................................................................

.....................................................................

.....................................................................

**319.**

"My most memorable hikes can be classified as 'Shortcuts that Backfired,'" said American author Edward Abbey. Last year, I got lost in a German forest with some friends. I thought I knew a shortcut, but it led us astray. Our phones weren't helpful, and one by one the batteries died anyway. When we finally found a remote house, we had the weirdest but most delightful conversation with the owner, who gave us homemade butterscotch cake and drinks. I will never forget the excitement once we were back on the right track again, laughing from relief, repeating strange things that had been said and done over and over again. In these digitally connected times we rarely get lost any more. But Edward Abbey was right. We forget that that is when the adventures happen; that's when you meet new people and discover unexpected places. **Use the space below to recall and write about a moment when you were lost.**

## 320.

To wander in the wild, you need good equipment. Wear sturdy shoes and a hat. Bring enough water, some salty snacks, and warm clothes. **Draw some things you want to bring on your trip.**

## 321.

Accepting that you don't know where to go is the first most important step when you're lost, otherwise you'll start running in circles, says John Huth, author of *The Lost Art of Finding Our Way*. Instead, take a break and come up with a strategy. Observe your surroundings and look for clues that can tell you which way to go. Look at how you relate to the sun and try to establish the wind direction. Huth advises we practice these skills in our normal life too. **Connect with your surroundings: Where is the sun? What way is the wind blowing?**

## 322.

To establish which direction is north, it can be helpful to look at trees. The side of the trunk that the sun doesn't reach is moister and often covered with moss. The part of the trunk the sun reaches is much dryer. You won't find moss there, but sometimes there are spots of algae, which is much lighter in color. The dry side will be facing south. **Draw moss on the different sides of this tree trunk.**

## 323.

Starting a new adventure in life or moving to a new place can also give you the feeling of being lost. You could even apply the same strategy as when you get lost in the forest: accept that you've lost control, and observe your surroundings. **Describe a time when you have felt lost in a new situation.**

........................................................................................................

........................................................................................................

........................................................................................................

........................................................................................................

## 324.

An ancient way to mark a trail is to stack a pile of stones called a cairn. For millennia, humans on every continent have used the stacking-of-stones technique for practical reasons, but it is also a peaceful thing to do; slowly placing stone on stone, trying to find the right balance.

## 325.

Don't just rely on the map to know where you are and where you're heading. Notice the changes in height and density of the forest. Take note of what kinds of trees and plants you're passing. Remember details. **Sketch a plant map from your walk with the help of your records.**

## 326.
........

During a walk, focus on only the
bizarre forms in nature: roots, trees,
an unusual rock. Let yourself be guided
by whatever sparks your interest.
**Afterward, draw one of the unusual
shapes you encountered.**

## 327.
........

We remember less about a beautiful scene when we photograph it.
Our mind automatically starts to depend on technology to do
the remembering. In addition, we are already anticipating the
reactions of others instead of experiencing the scene fully.
If you want to create a memory in your head, you'd better leave
the camera in your bag. **Instead, make a little sketch.**

# 328.

"From day to day keep your log, your day-book of the soul," writes Stephen Graham in *The Gentle Art of Tramping* (1926). "You may think of it as a mere record of travel and facts; but something else will be entering into it, poetry, the new poetry of your life." **Keep a log of where you go this week. Let some poetry slip into it.**

# 329.

"Climb the mountains and get their good tidings. Nature's peace will flow into you as sunshine flows into trees." This is a quote from *The Mountains of California*, written by John Muir and published in 1894. Muir was an essayist and environmental philosopher who was also known as "John of the Mountains." The mountains were his sanctuary, a place where everything else seemed relative. Many writers and poets have serenaded mountains: their vastness, the tangible evidence of the power of the earth, the adventure; for many people they are irresistible. As Jack Kerouac wrote: "Because in the end, you won't remember the time you spent working in the office or mowing your lawn. Climb that goddamn mountain." The showy top of a mountain turns golden in the light of the evening sun. **Color these mountain tops.**

## 330.
..........

Perform a mountain meditation. Close
your eyes and think of a mountain.
Imagine you are that mountain. You
are thousands of years old; you are
huge and rise above everything else.
Everything happening to you is just
temporary and leaves you untouched.

## 331.

Mountain goats climb the steep slopes of mountains without effort. What's their secret? It's the way they're built, obviously. But there are lessons to be learned for humans. A tip from experienced climbers is to be like a goat and not look up all the time. Holding your head up also brings unnecessary tension to your body. The keys to successful climbing are to keep a relaxed pose, look at where you are placing your feet, and to breathe evenly.

## 332.

*Yugen* is the Japanese word for the mysterious sense of unity with the universe that you can feel sometimes when alone in nature. You are most likely to experience it when on a misty mountain. **Describe a moment when you felt at one with nature.**

## 333.

A goddess, a sleeping giant, an old man's face, an elephant—rock formations and mountains sometimes resemble a particular creature. **Draw a rock formation or a hill with the form of an animal or person.**

## 334.

Needle-leaved trees are often found in the mountains. If the needles grow clustered in a group of two or more, the tree is a pine (*Pinus*). If the needles grow individually, it's a fir (*Abies*) or spruce (*Picea*). The difference between a fir and a spruce is that a fir has flat needles, while spruce needles are four-sided and sharply pointed. **Look for a needle-leaved tree and see if you can identify it.**

## 335.

The relief and euphoric feeling when you reach the top of a hill or mountain after a long climb is unsurpassed. Both scary and impressive at the same time, it generates a feeling of awe. **Draw a mountain view.**

**Common swift**
6,215 miles (10,000 km)

# 336.

Some animals travel across incredible distances when they migrate. The common swift can spend ten months in continuous flight, even sleeping and eating in the air. The birds dislike being on the ground so much that people used to think they had no feet at all. It's interesting to wonder whether the birds and animals you see are travelers of the world or prefer to stay in one place. **What kind of animal are you?**

**Salmon**
2,360 miles (3,800 km)

**Leatherback sea turtle**
12,400 miles (20,000 km)

**Northern elephant seal**
13,000 miles (21,000 km)

## 337.

When we look at nature, it is always from our own viewpoint. Biologist Charles Foster, author of *Being a Beast*, wanted to figure out how animals see the world. He lived like a badger for a while in a sincere attempt to see the world from an animal's point of view. **Try to see the world from the perspective of one of the other animals on this page. What does it encounter? What does it see on its journey?**

........................................................................

........................................................................

........................................................................

........................................................................

........................................................................

## 338.

When traveling by train or as a car passenger, you
see the world passing you by, landscapes changing
from urban to rural to urban. All those transitions
foster the meandering of the mind. Leave your phone
in your bag and listen to your thoughts instead.
**Make notes of everything that comes to mind as you
look at the world passing by.**

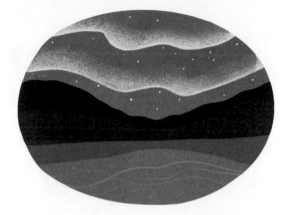

# 339.

Look at the natural wonders checklist below. Which would you like to visit? What natural sights have you already seen that blew your socks off? **Add your own natural wonders to the list.**

A giant sequoia tree

A roaring waterfall

A glacier bathed in morning light

A cherry blossom park in springtime

A rain forest in the mist

A desert sunset

The northern lights (aurora borealis)

Heather fields in the evening sun

A towering cliff

......................................................................................................

......................................................................................................

......................................................................................................

......................................................................................................

......................................................................................................

# JUST BREATHE

Whenever I was stuck, stressed, or simply having an afternoon slump, like many of us, I used to just drink another cup of coffee. Lately, however, I go outside instead. A 20-minute walk in the park turns out to have a far better effect on me than a cup of joe. I often come back to my desk bursting with new energy, and I even have new ideas and solutions to problems.

A lot has been said about the restoring effect of nature. But it turns out that the effect is even more profound when we are physically active in nature. Since 2003, the University of Essex in England has been running a scientific research program called Green Exercise. Researchers found that people who do their workout in a forest or park are happier and less tired afterward, experiencing a long-lasting energy

boost. And being physically active in nature turns out to have many other positive effects, both long and short term, such as higher self-esteem and a happier mood. This is the case for everyone: young, old, woman, man, no matter what background or nationality. By combining nature and exercise, you hit the well-being jackpot!

Essentially, nature has everything we need to make us feel better. It calms us down as well as energizes us. It stimulates us and connects us. In this chapter, you'll find prompts to make your heart beat faster and slower. Because as well as exercising, nature is also the best place to meditate, to be at one with your surroundings. Our lives in the city can be exhausting. Sometimes we just have to get back to nature and breathe.

## 340.

We do feel better after a workout in a green environment—that's a fact. But sometimes it's hard to get motivated. It's no wonder: We have evolved to save up energy. We have to fight our natural impulse to choose the lazy option. A good tip to help you overcome any resistance is to commit to starting and nothing else. **Don't set a big goal; don't overthink it; just start with a two-minute warm-up. Once your blood starts flowing, your reluctance will melt away.**

## 341.

Just a short burst of energy can have a significant positive impact on your mood when you are in nature—even doing something as simple as jumping jacks. **Stand with your feet together and your arms by your side. Hop and land with your feet apart at the same time as bringing your arms above your head. Then hop again and bring your feet and arms back together again. Repeat this until you feel your heart rate rising and your blood pumping.**

The philosopher Henry David Thoreau
believed that, "An early morning
walk is a blessing for the whole
day." **Go out in the early morning
for a run or a brisk walk to see
the sunrise. The air will still be
moist, with dew drops covering the
ground and everything on it. Come
home refreshed and ready for the
rest of the day.**

Swimming in open water will
make you stronger, mentally
and physically. There is some
scientific evidence that regular
wild swimming can ameliorate mild
depression symptoms. **Put on a
wetsuit and head to the nearest
body of natural water where you
can swim.**

In his book *Mindful Thoughts
for Cyclists*, Nick Moore says:
"There's nothing wrong with
confining your cycling to
warm summer days, but for true
understanding, we must know cold,
not just heat, and embrace the
dark as well as the light." **Take
a bike ride on a cool, crisp
morning and feel the cold,
fresh air reinvigorating you.**

## 345.

To fight the afternoon slump at work, don't automatically reach for the coffee; instead, stand up and go for a short walk. Brain research has shown that walking stimulates part of the brain that functions as an engine for your mind. This enhances mental arousal, helping you to think more clearly. That's why walking meetings are far more inspiring and productive than trying to force concentration in a brightly lit meeting room. **Make notes of when you can arrange a walking meeting instead of a sitting one.**

...........................................................................................................

...........................................................................................................

...........................................................................................................

...........................................................................................................

...........................................................................................................

## 346.

Stop the rush! Don't forget to take a moment for yourself on a workday. When you're on your way from A to B and you're stressed and worried, take a side route through the park and stop for a couple of minutes. You can always spare two minutes. Sit down and listen. Keep your senses active. Can you hear the grass grow? **Write down what else you notice.**

...........................................................................................................

...........................................................................................................

...........................................................................

...........................................................................

...........................................................................

...........................................................................

...........................................................................

## 347.

While you're talking about or working on something that makes you feel stressed, you can prevent yourself from feeling completely overwhelmed by using a simple trick. Keep something on hand that connects you with a sweet nature memory, for example, a stone or a shell. By merely touching it occasionally and becoming aware of the sensation of the object against your skin, it can act as a helpful reminder of a calmer place. **Draw a natural object that connects you to a calming memory.**

## 348.

Forest sounds calm us down and make us feel more focused. Thanks to the Internet, we have easy access to all kinds of nature sounds: frogs, leaves rustling, birds, beetles—you can find hours of recordings online. **Search for nature sounds and fill your home or office with them.**

Herbs have long been an integral part of taking care of ourselves. For every little pain, our ancestors knew a natural remedy. On this page are herbs that can reduce anxiety. Pour hot water over their dried leaves and flowers. Savor the aroma and drink the infusion with a mindful presence. "Only in the awareness of the present, can your hands feel the pleasant warmth of the cup," according to Thich Nhat Hanh.

Jasmine
(*Jasminum*)

Valerian
(*Valeriana officinalis*)

Sweet basil
(*Ocimum basilicum*)

Bergamot
(*Citrus bergamia*)

Fennel
(*Foeniculum vulgare*)

Chamomile
(*Matricaria chamomilla*)

Marjoram
(*Origanum majorana*)

## 350.

One way to gently extract a herb's healing power is to make sun tea—for example, try using chamomile. **Clean a bunch of chamomile flowers and add them to a jar of cold water. Let it stand in the sun for several hours, then remove the flowers. Sweeten the resulting infusion with some honey. Let it cool down, then add ice cubes, a slice of lemon, some mint leaves, and fresh chamomile flowers.**

## 351.

For most animals, scents are the best and sometimes the only way to communicate. They use them to attract mates, to scare predators, and to fool other animals. We humans use our noses much more then we realize. **Try to be aware of the scents around you today, and note whether they attract or appall you.**

Attract:

........................................................................................................

........................................................................................................

........................................................................................................

Appall:

........................................................................................................

........................................................................................................

........................................................................................................

## 352.

It is possible to "see" even without looking. Find a nice place to sit down and start counting the sounds you hear. What can you hear nearby and in the distance? Once you think you've noticed all the sounds around you, hold on for one more minute—one or two more sounds will probably come to you. **Write them down here.**

........................................................................................................

........................................................................................................

........................................................................................................

........................................................................................................

........................................................................................................

# 353.

Who needs the gym if you have a park? You can create your own exercise routine around your yard or park. Jump over logs, stretch against a tree, make running more interesting by avoiding things on the ground, such as twigs or leaves. That way you're not only training your body but also your cognitive capacities. **Design an exercise plan that works in your outside space and draw the different activities here.**

Before you start an activity, any activity, focus briefly on your breathing. End the activity with a moment to focus again on your breathing, learning to tune in to the quality of the breath. **Doodle some flowers in this space while concentrating on your breathing.**

## 355.

Qigong and tai chi are ways to guide your energy (*chi*) as it moves through and around your body. They can help many people to find inner peace and strength. When performed outside in nature, these activities can be extra special. Here's a simple qigong exercise: With your arms by your side, raise your hands from your hips to chest height with palms facing up while breathing in; return them, with palms facing down, while breathing out. Feel the difference when moving your arms up and down.

## 356.

Is hay fever stopping you from going outside? Herbalists say elderflower is beneficial when you have hay fever. To make elderflower syrup, you need 12 fresh heads of elderflower, 1 cup (200 g) granulated sugar, and 1 cup (250 ml) water. Bring to a simmer, turn off the heat, and let it steep for an hour, then strain it. You can use this syrup for all kinds of drinks.

## 357.

We have so many different thoughts throughout the day that we become disconnected from our bodily sensations. But, when you think about it, your body is a living work of art. See whether you can feel your blood running through your body, from your heart all the way to your fingernails—and back. **Draw some veins on this hand.**

## 358.

If you've seen a dog getting up after a nap, you'll know immediately why there is a yoga asana (position) that is called "downward-facing dog." It is generally the first move that a dog makes after waking up. Harvard University researchers say that people should stretch every day to keep their joints flexible. Make it a habit to stretch every time you get up from a resting position—just like a dog.

## 359.

It feels great to hug a tree sometimes. It may be an activity that's frowned upon or ridiculed by some people, but this simple act will put a smile on your face. Look for a large tree. Wrap your arms around it, let your cheek touch the bark, and inhale the scent. **How does it make you feel?**

## 360.

Silence and tranquility foster creativity and clear thinking. If you can find a nature hide, sit in it for a while and be silent.

## 361.

Do you know all the green areas in your town or city? Are there public gardens you might not know of? Check a map and go out and explore the areas of green on a run or a brisk walk. **Note where you've found a green space in your area, however small.**

........................................................................................

........................................................................................

........................................................................................

........................................................................................

## 362.

To take it slowly, we could look at the tortoise for inspiration. Never in a rush, slowly moving his legs one by one. When they're threatened, they just take shelter in their bony shell. You don't need to be fast when you are that strong. **What do you gain by moving fast? Can you win something by moving slower?**

## 363.

A frog is the perfect example when meditating, according to mindfulness therapist Eline Snel, author of *Sitting Still Like a Frog*. The frog can make huge jumps, but it can also sit particularly still. He notices what is happening around him, but does not respond immediately. He breathes and sits still. His belly bulbs up and sinks again. And what the frog can do, we can also, says Snel. **Sit still like a frog and make notes afterward.**

## 364.

Slow down. Try to walk as slowly as you can. If you're feeling annoyed, just continue walking for a little while longer. **Try to observe your feelings without judgment and note them here.**

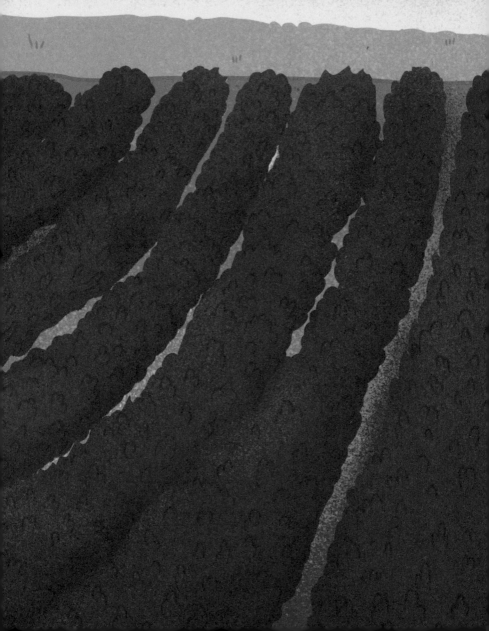

# 365.

There is something magical about a purple field. If you can, make plans to visit a lavender field in the peak of summer, when it's in full bloom. Meanwhile, give yourself a footbath with lavender oil.

# FURTHER READING

**Books**

*Biophilic Cities; Integrating Nature into Urban Design and Planning*, Tim Beatley (Island Press, 2010)

*Forest Bathing; How Trees Can Help You Find Health and Happiness*, Dr Qing Li (Viking, 2018)

*Last Child in the Woods; Saving our Children from Nature-Deficit Disorder*, Richard Louv (Atlantic Books, 2010)

*Shinrin-yoku; The Japanese Way of Forest Bathing for Health and Relaxation*, Yoshifumi Miyazaki (Aster, 2018)

*Blue Mind; How Water Makes You Happier, More Connected and Better at What You Do*, Wallace J. Nichols (Little, Brown, 2014)

*The Nature Fix; Why Nature Nature Makes Us Happier, Healthier, and More Creative*, Florence Williams (W. W. Norton, 2017)

*The Hidden Life of Trees; What They Feel, How They Communicate*, Peter Wohlleben (Greystone Books, illustrated edition, 2018)

**Articles**

"Natural Sounds Improve Mood and Productivity," Acoustical Society of America, *Science Daily*, May 2015

"What is the best dose of nature and green exercise for improving mental health? A multi-study analysis," J. Barton & J. Pretty, *Environmental Science and Technology*, May 2010

"The cognitive benefits of interacting with nature," Mark G. Berman, John Jonides & Stephen Kaplan, *Psychological Science*, December 2008

"A difference-in-difference analysis of health, safety, and greening vacant urban space," Charles Branas et al, *American Journal of Epidemiology*, December 2011

"Nature Experience Reduces Rumination and Subgenus Prefrontal Cortex Activation," Gregory N. Bratman et al., *Proceedings of the National Academy of Sciences of the USA*, July 2015

"The relationship between nature connectedness and happiness: a meta-analysis," Colin A. Capaldi, Raelyne L. Dopko, & John M. Zelenski, *Frontiers in Psychology*, September 2014

"A Lunchtime Walk in Nature Enhances Restoration of Autonomic Control during Night-Time Sleep: Results from a Preliminary Study," Valerie F. Gladwell et al, *International Journal of Environmental Research and Public Health*, March 2016

"Nature connectedness: Associations with well-being and mindfulness," A. J. Howell et al, *Personality & Individual Differences*, July 2011

"The perceived restorativeness of gardens – assessing the restorativeness of a mixed built and natural scene type," Carina T. Ivarsson & Caroline M. Hagerhall, *Urban Forestry and Urban Greening*, May 2008

"Physiological and psychological response to floral scent," H. Jo et al, *HortScience*, January 2013.

"Aerosol generation by raindrop impact on soil," Young Soo Joung & Cullen R. Buie, *Nature Communications*, January 2015

"40-second green roof views sustain attention: The role of micro-breaks in attention restoration," Kate Lee et al, *Journal of Environmental Psychology*, June 2015

"Underestimating Nearby Nature Affecting Forecasting Errors Obscure the Happy Path to Sustainability," Elizabeth K. Nisbet & John M. Zelenski, *Psychological Science*, September 2011

"The Mammalian Diving Response: An Enigmatic Reflex to Preserve Life?" W. Michael Panneton, *Physiology* (Bethesda), September 2013

"Noticing nature: Individual and social benefits of a two-week intervention," H. Passmore & M. Holder, *The Journal of Positive Psychology*, 12:6, 2016

"Green Mind Theory: How Brain-Body-Behaviour Links into Natural and Social Environments for Healthy Habits," J. Pretty, M. Rogerson & J. Barton, *International Journal of Environmental Research and Public Health*, June 2017

"Quantification of Overnight Movement of Birch (*Betula pendula*) Branches and Foliage (...)" Eetu Puttonen et al, *Frontiers in Plant Science*, February 2016

"Bird sounds and their contributions to perceived attention restoration and stress recovery," Eleanor Ratcliffe, Birgitta Gatersleben & Paul T. Sowden, *Journal of Environmental Psychology*, December 2013

"Humans and Nature: How Knowing and Experiencing Nature Affect Well-Being," Roly Russell et al, *Annual Review of Environment and Resources*, October 2013

"Gardening is beneficial for health: A meta-analysis," Masashi Soga & Kevin J.Gaston, *Preventive Medicine Reports*, March 2017

"Stress Recovery During Exposure to Natural and Urban Environments," Roger S. Ulrich et al, *Journal of Environmental Psychology*, September 1991

"Well-Being of Allotment Gardeners: A Mixed Methodological Study," Jo Webber et al, *Ecopsychology*, March 2015

"Blue space: the importance of water for preference, affect, and restorativeness ratings of natural and built scenes," Matthew White et al, *Journal of Environmental Psychology*, December 2010

# ACKNOWLEDGMENTS

First, my gratitude goes out to Mother Earth, our beautiful, intriguing, perfect blue planet. Let's keep her beautiful together. Thank you to all the scientists who carry out important research on nature.

Thank you for sharing your knowledge and thoughts with me: Wim and Yolanda de Kwant, Daniel Hoekstra, Judith Kluiver, Rogier Besemer, Suzanne Wardenaar, Ivo Tanis. Big thanks to Dr. Ross Cameron.

Thank you Leaping Hare's Monica, Joanna, Graham, Susan, and Tom, thank you for being awesome and giving this Dutchy your trust. A thousand thanks to Clare for the illustrations and to Tonwen, Anna, and James for the design.

And lastly my kids, Suzy and Milo, and my always handsome, funny, and patient husband Robin.